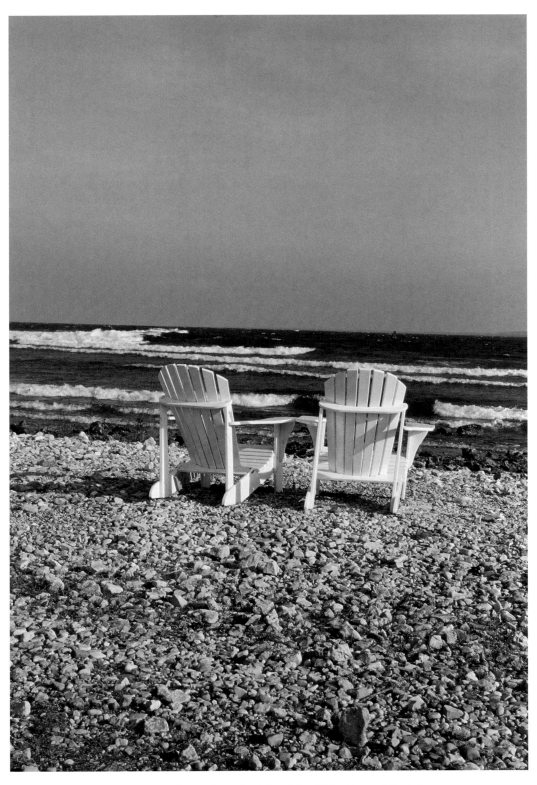

Mission Point chairs along the sight of the 1908 shipwreck Peshtigo,
which sunk just beyond the red buoy.

Manufactured in Canada
2006 2005 2004 5 4 3 2 1
ISBN 0-472-11444-1

Signed Limited Edition Prints
http://www.webspawner.com/users/islandimage/index.html
http://www.asmpmichigan.org/Phipps.htm
phipps@gtii.com

SEASONS OF
MACKINAC

PHOTOGRAPHY BY TERRY W. PHIPPS

The University of Michigan Press
Ann Arbor
and
The Petoskey Publishing Company
Traverse City

For my daughters
Makena Elizabeth Phipps
& Liliana Kai Phipps

Special thanks to
Margaret Rose Kelly-Braden for her editing
Jim DeWildt for his design work
Mary Erwin, University of Michigan Press
Brian Lewis, Petoskey Publishing
and
Len Trankina, Executive Director, Tourism Bureau
Mackinac Island Tourism Bureau
the Traverse Area District Library
the Victor Callewaert family
Ron and Mary Dufina
Peter Dewey
the Arnold Transit Company Island Ferry
the Star Line Island Ferry
Shepler's Island Ferry
for their support

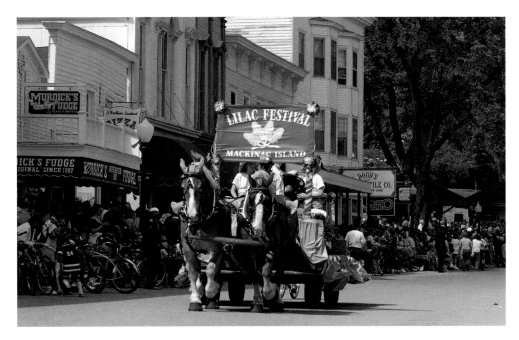

The Lilac Festival, held every June.

PREFACE

As the summer season begins to wane, and the ferry schedules thin, people have often wondered about the secrets the Mackinac Island keeps tight to its vest. Like a card game where jokers are wild, luck finds its way to those who would bet on an off-season hand. It's not that the summers are unpleasant, it's just the hordes define the better times. Over one million visitors cross the Straits of Mackinac, Lake Huron side, to reach this tiny Victorian vestige. Familiar to most as a summer vacation destination, day people catch a ferry flotilla that spans the horizon from daylight to dark delivering nary a glimpse to island life but satiating most with wide-eyed memories. From departure to return, the adventure begins aboard one of three ferry lines making their way across the straits from either Mackinaw City or St. Ignace, past Round Island and Mackinac Island harbor lights, into another time.

June exemplifies the island's finest summer days. For overnighters, an unexpected ambience, twilight strolls, sunrise paddles and early rides around the island define its solitude and lends insight to this idyllic island life. The aroma of lilacs sweep down the boulevards on the light morning breezes. Shops are still spring paint fresh, and all the flowers color the landscape in a blend of hues yet unnamed. Horses display their exuberance with a persistent cadence, and the locals smile uncontrollably; perhaps it's a renewal. With all the obvious trappings where tourists flock when first herded off the docks, there still are nuances not to be missed: Windermere Point picnics, Market Street in the morning, the Grand at sunset, the Mission Point chairs in afterglow, the Butterfly House on sunny days, Ste. Anne's Church when it rains, and an afternoon lying on a blanket in Marquette Park are a few of my favorite things.

Declared as the second National Park by Congress in 1875, the island currently remains in the Michigan state park system. Eighty-one percent of the island is owned by the State Park. Impressive trail systems and roads weave the twenty-two hundred acres, and its main highway, M-185, is the only highway never to have an auto accident; automobiles were banned in 1898. Its history can be projected as far back as the Woodland Period when nomadic people came to fish. Artifacts currently predate the Europeans' arrival by seven hundred years. Jean Nicolet discovered "Mishi-minauk-in-ong" in 1634, and from that point Mackinac Island became a strategic economic interest worth defending. Fort Mackinac attests to its enduring history.

Just before the north winds deliver their first blow, and flakes the size of fists pelt peeling panes high along the fort's weathered buildings, an exquisite moment comes to the island. It is the calm before winter's onslaught. It is the sound of metal spring rakes pulling crimson maple leaves in piles so the autumn rains can reduce them to a Monet. It is the echoing of hooves along empty morning streets and ambling walks wandering in no particular direction. At no time does serenity roar more than in a Mackinac Island off-season.

Terry W. Phipps

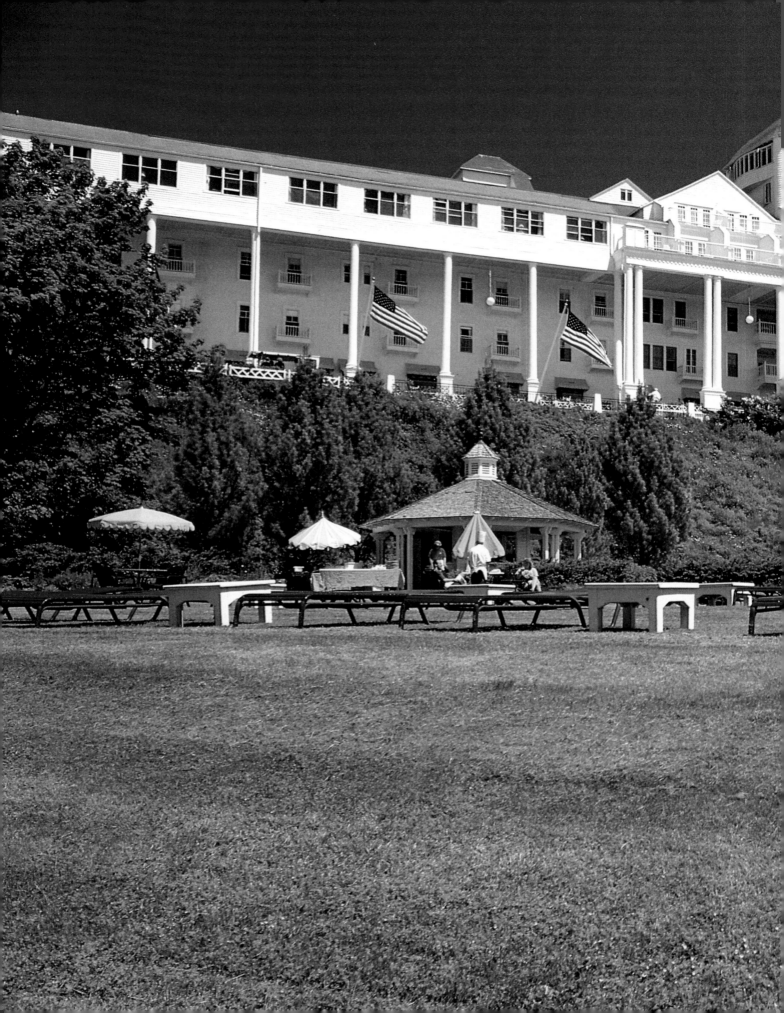

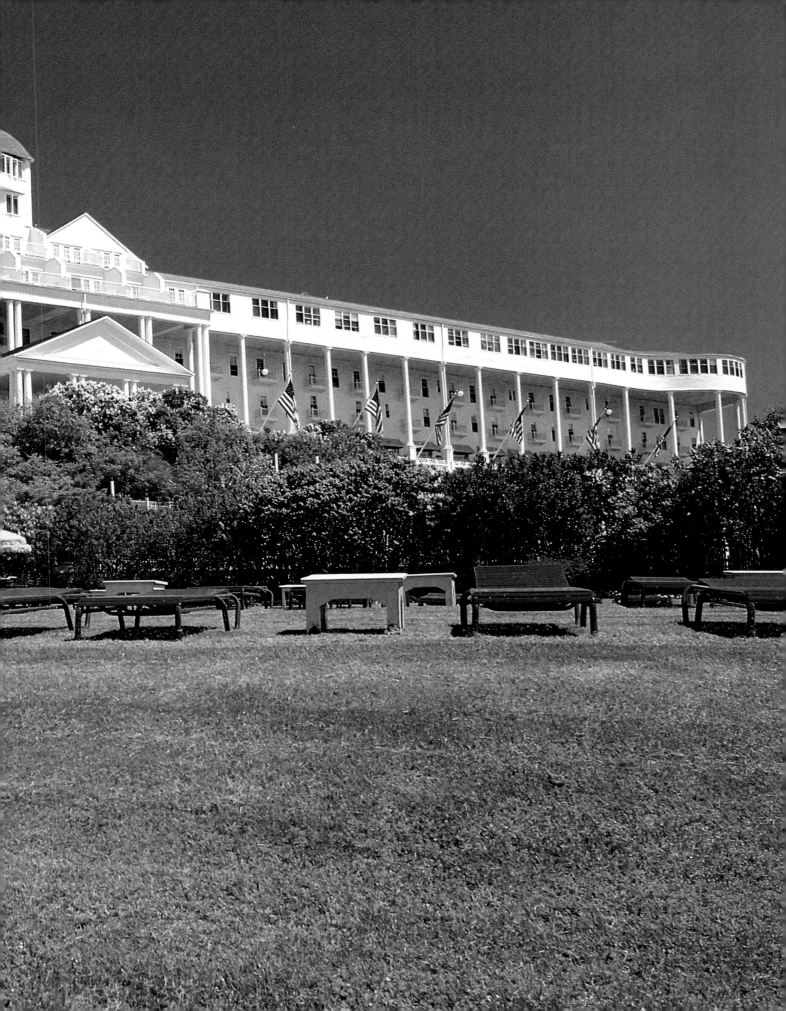

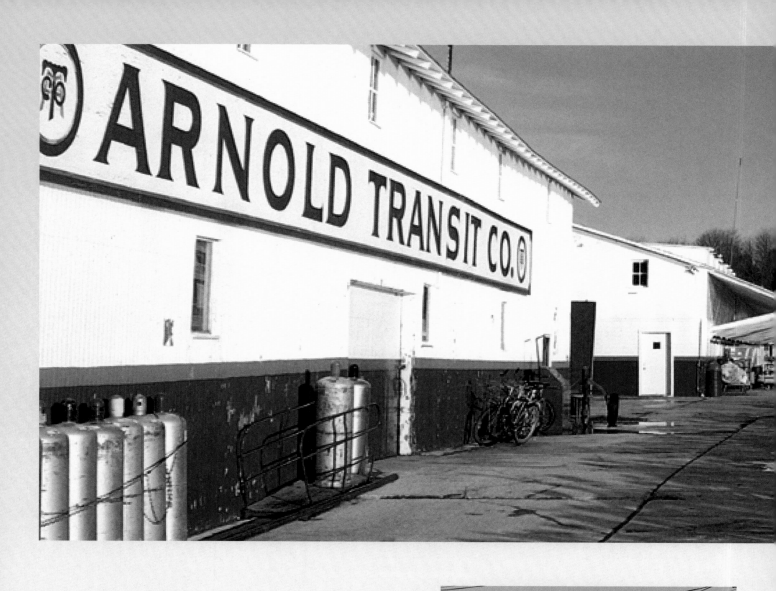

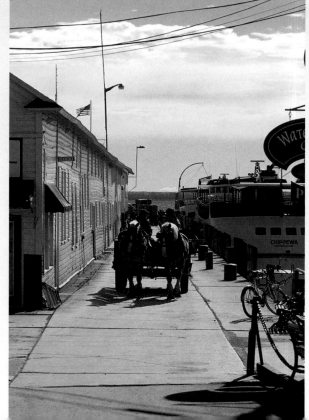

Horse drawn drays on Arnold docks.

Previous page:
The magnificent Grand Hotel.

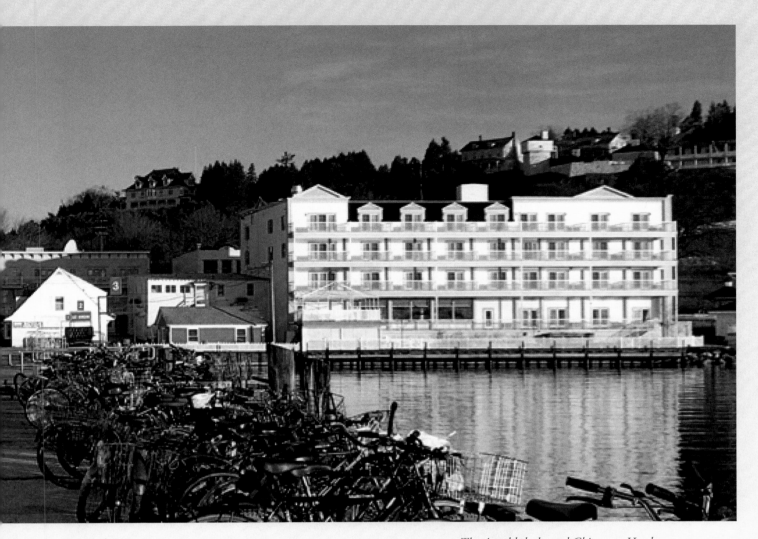

The Arnold docks and Chippewa Hotel.

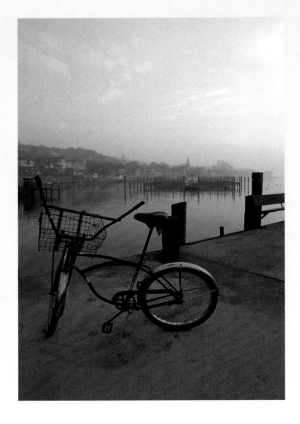

*Overlooking the marina
on a foggy morning.*

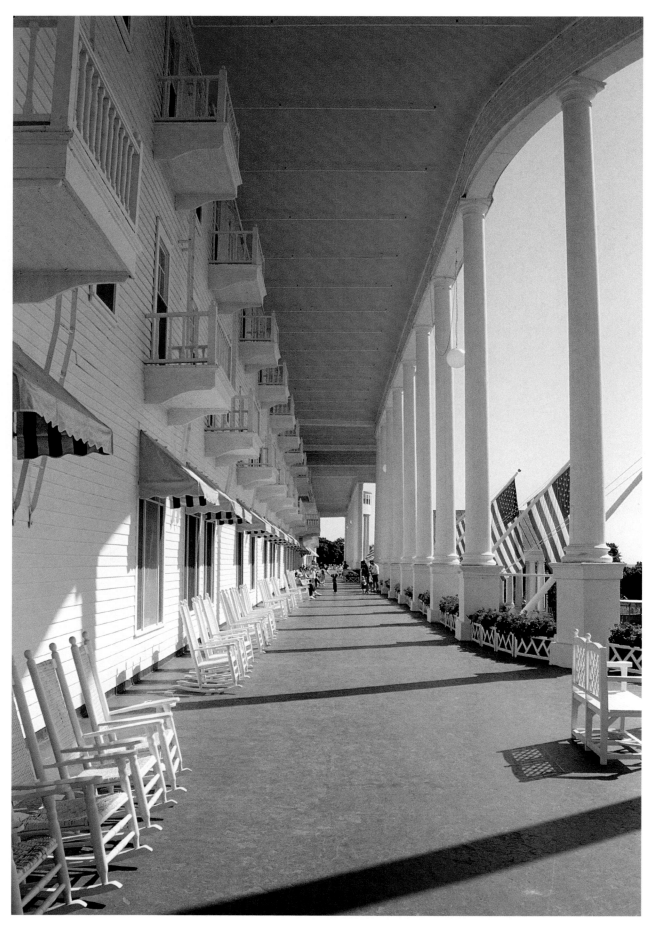

The Grand Hotel's famous 700 foot veranda. The hotel opened as Plank's Grand Hotel in 1887.

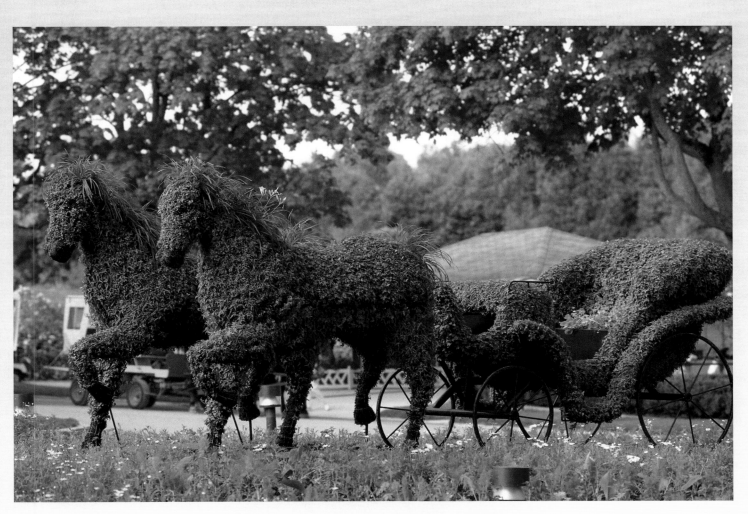

The Grand's exquisite gardens.

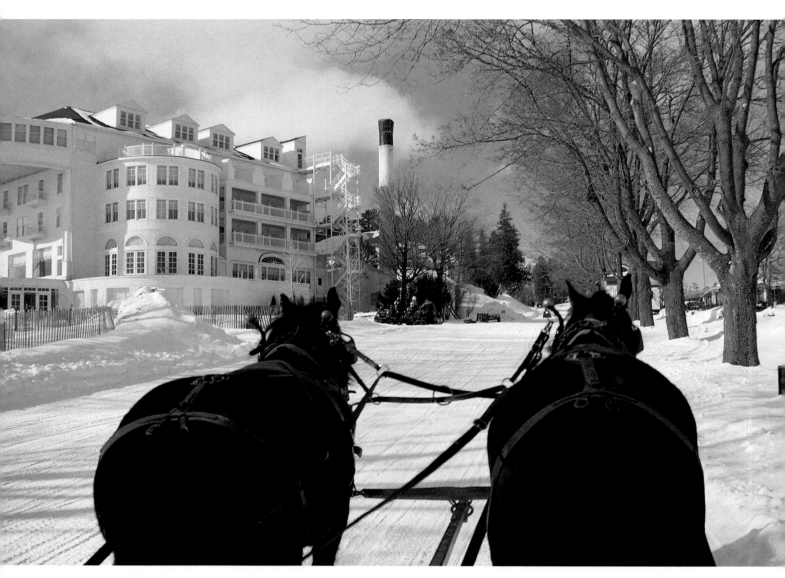

A taxi ride past the Grand toward the airport.

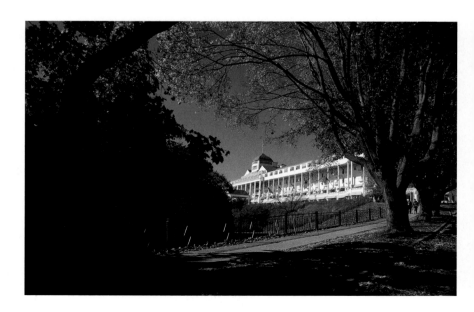

*The Grand framed
by blazing hues.*

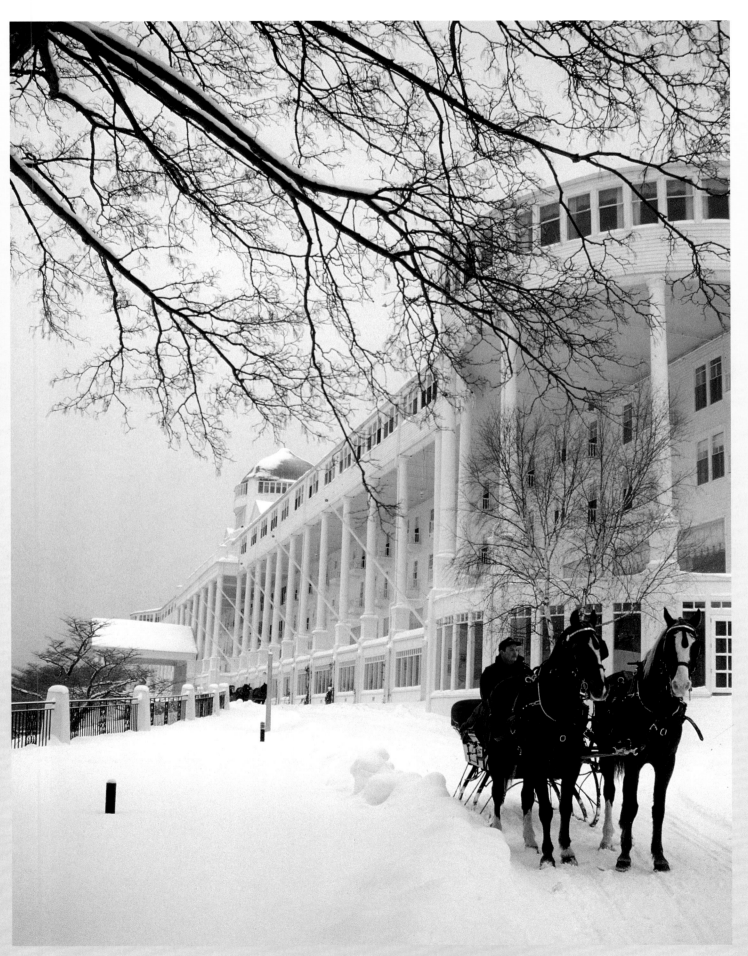

Winter along the Grand's face.

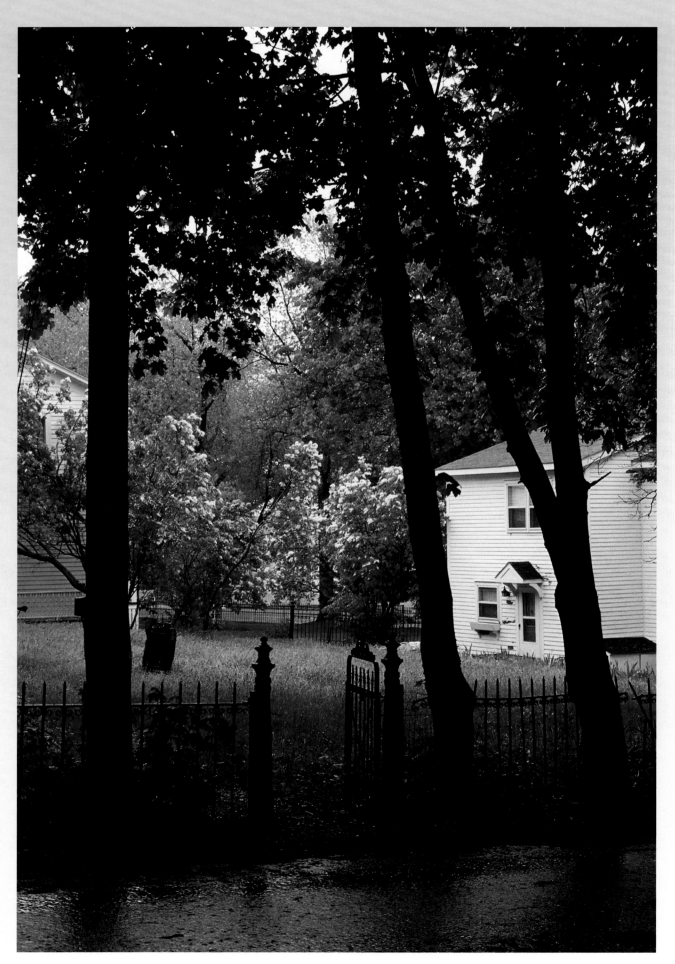

At the end of McGulpin Street.

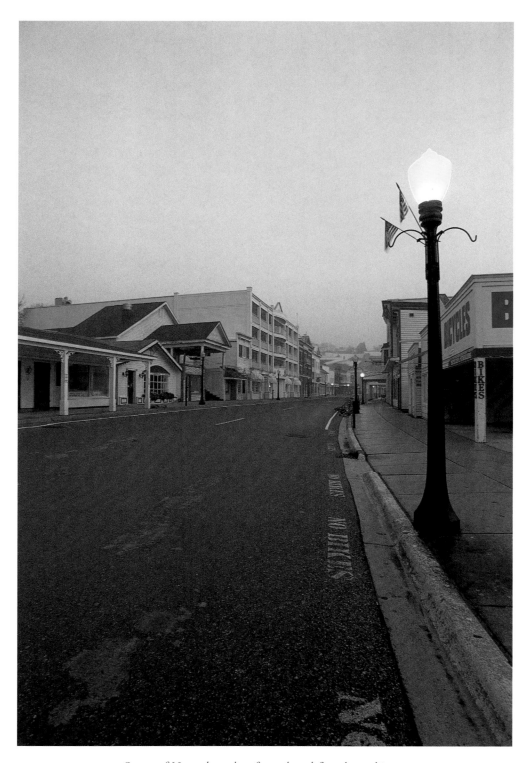

Streets of November when foggy days define the ambiance.

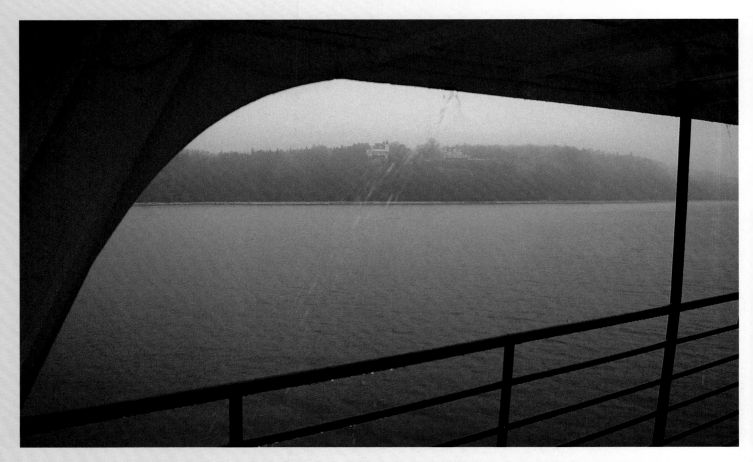

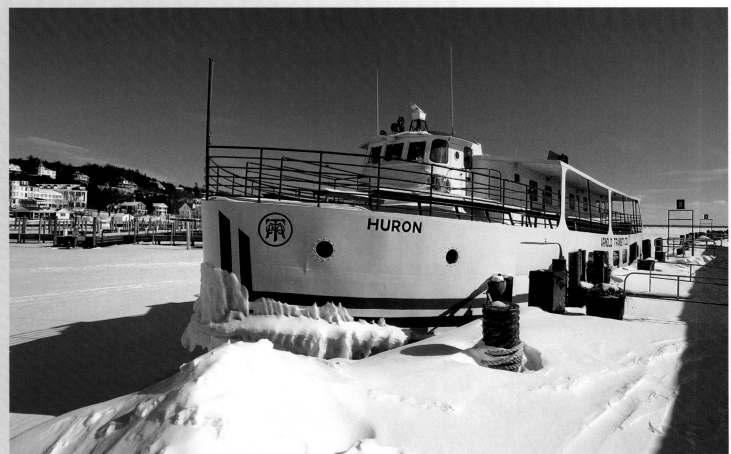

After December, ferries usually come to a halt as ice surrounds the island.

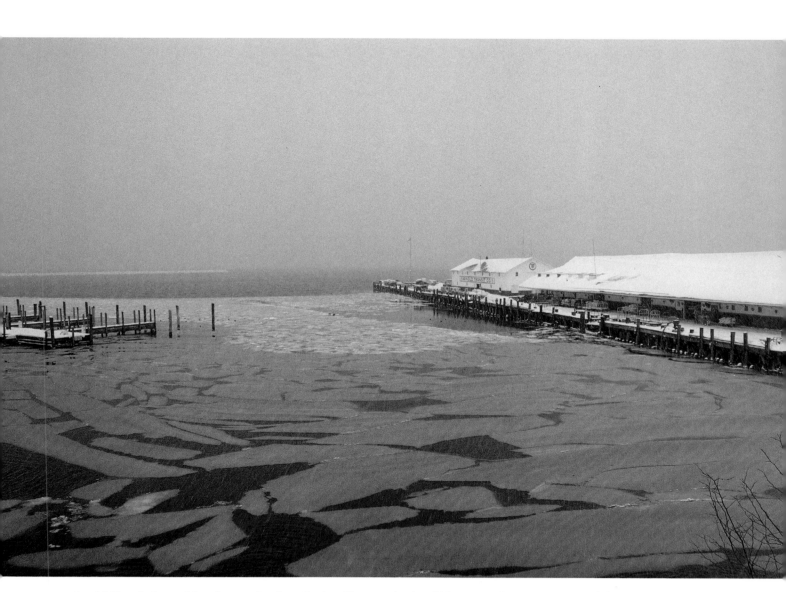

Arnold Line docks awaiting the morning ferry. In the off-season, the Arnold Line runs from St. Ignace until the ice moves in.

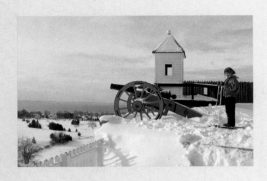

Nordic skiing through Fort Mackinac offers spectacular views.

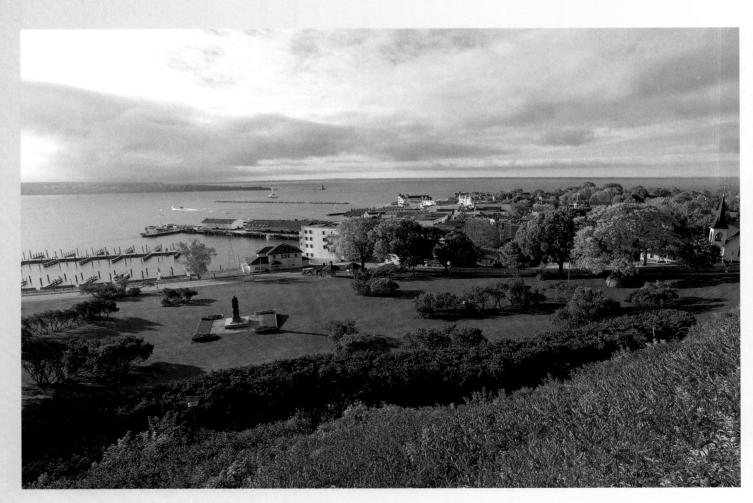

Autumn comes to Marquette Park.

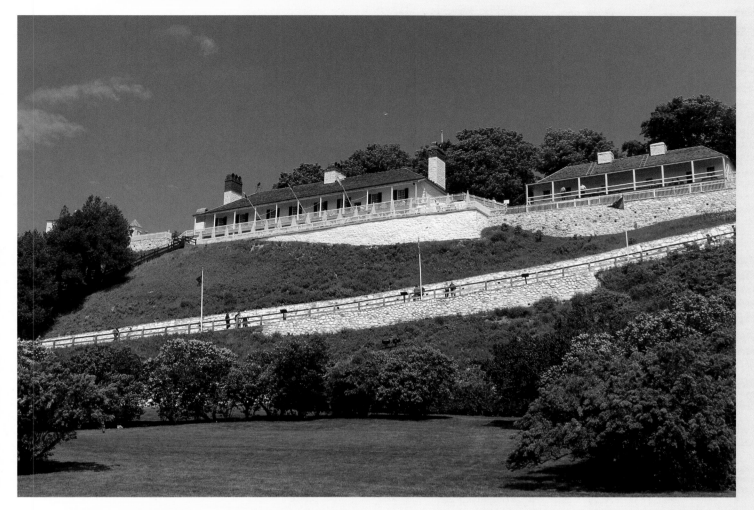

Marquette Park with Fort Mackinac's white-washed stone walls providing a backdrop. The officers' stone and wooden quarters sit on top of the wall.

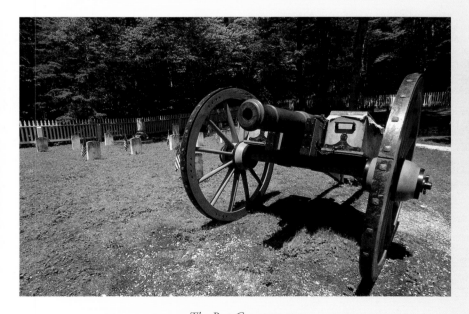

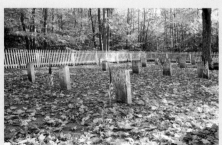

The Post Cemetery holds 142 graves of those military personnel and their families who died while on duty at Fort Mackinac. It is believed six British soldiers from the War of 1812 are buried here.

The Post Cemetery.

Following page:
After the day crowds leave, the
island's charm changes.

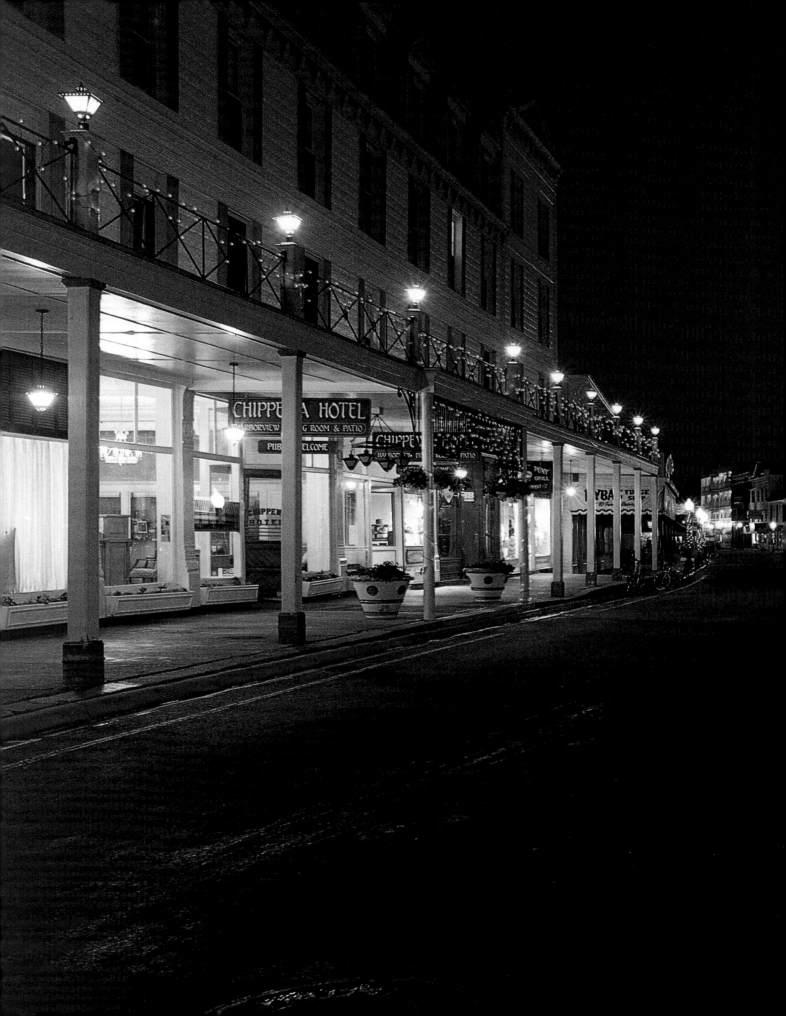

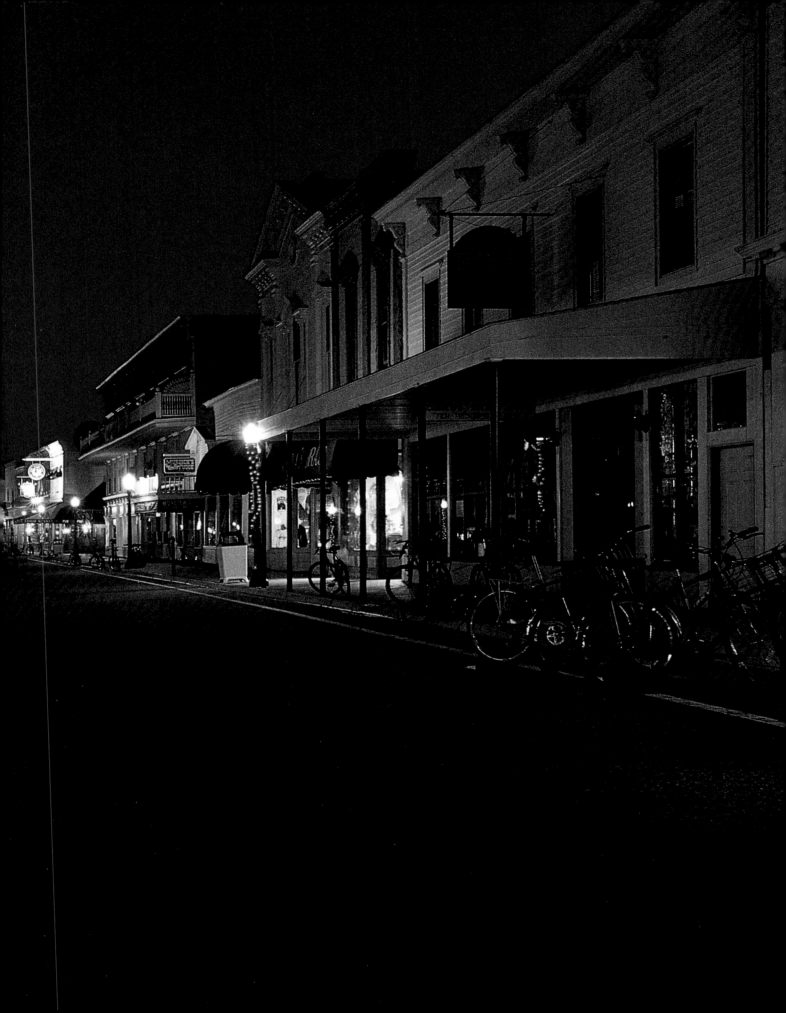

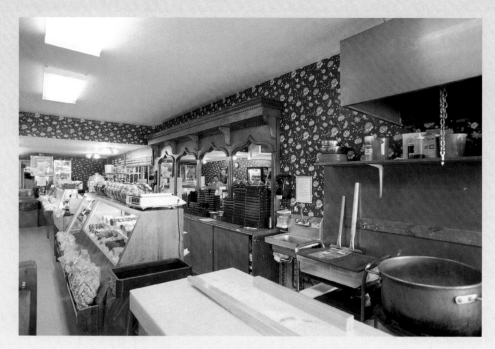

The fudge, cooked in large copper kettles and poured on cool marble slabs, was introduced to the island over 100 years ago.

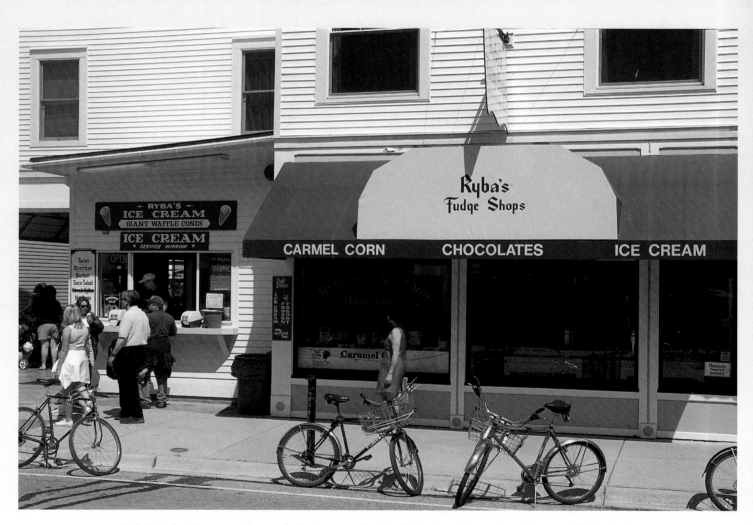

Ryba's Fudge Shop, one of many fudge shops on the island. Together, they produce five tons of fudge daily.

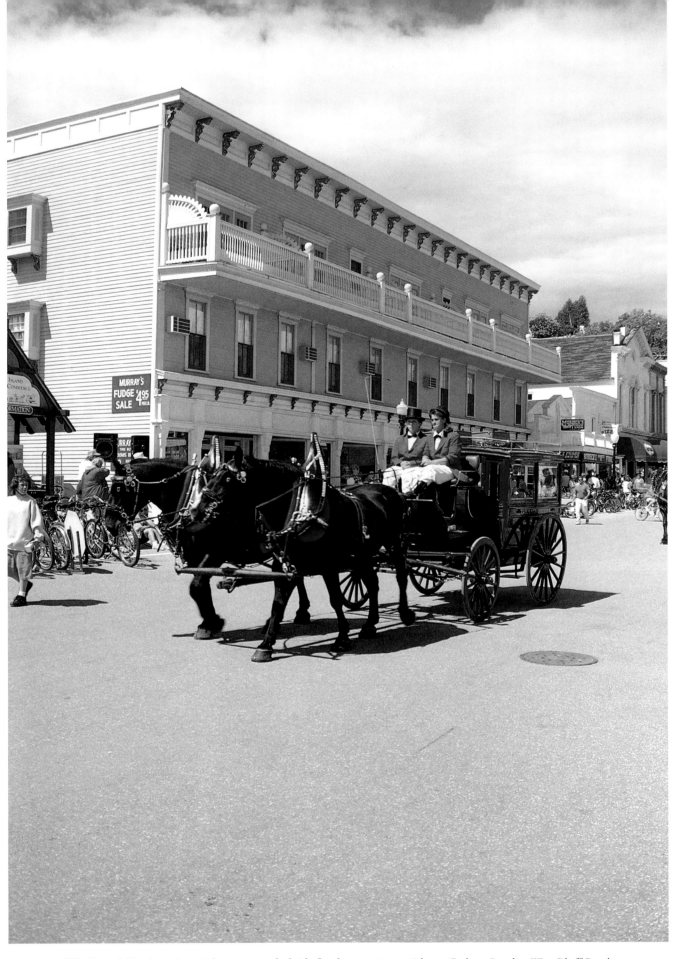

The Grand Hotel carriage picks up guests dockside for the ten minute ride up Cadotte Road to West Bluff Road.

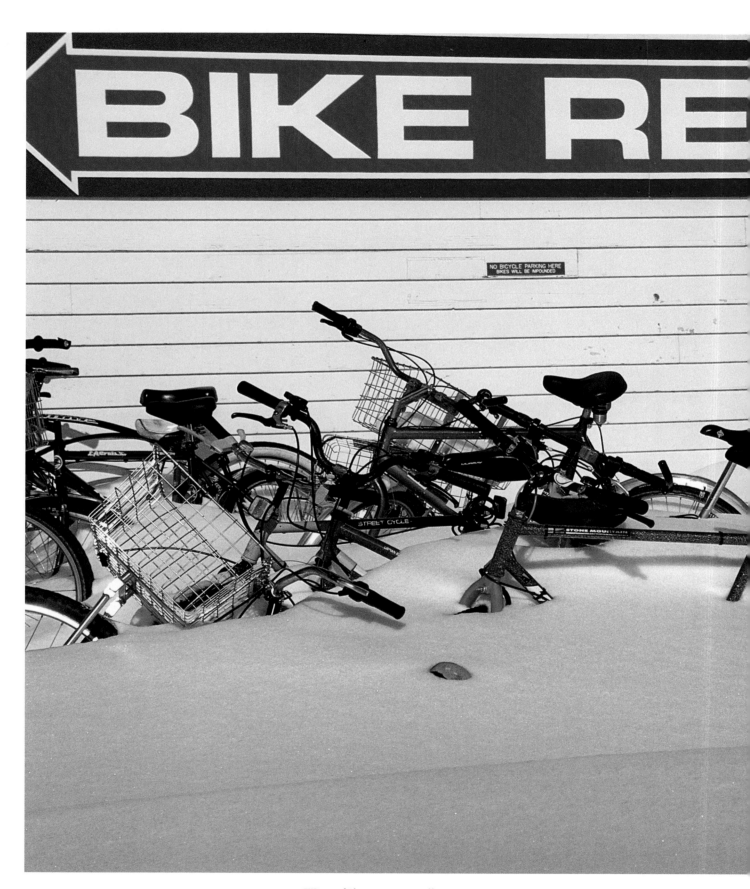

Winter bike storage—really.

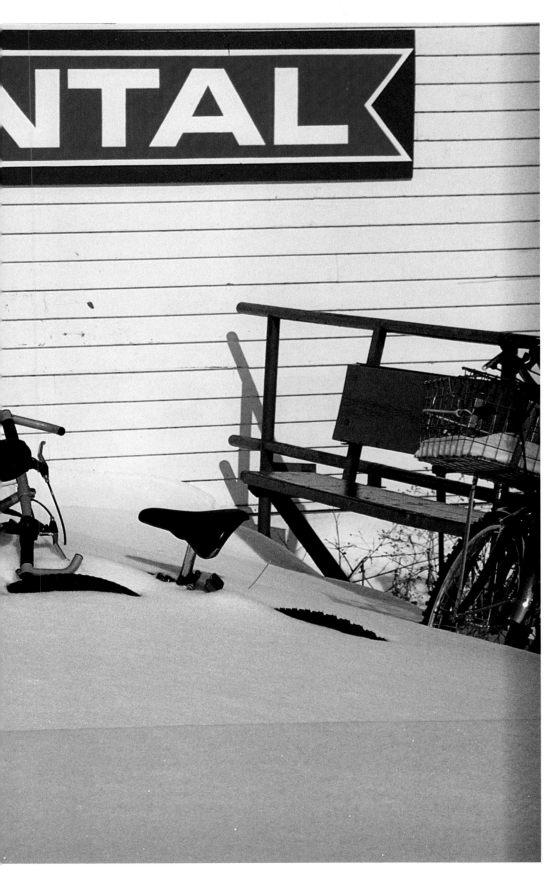

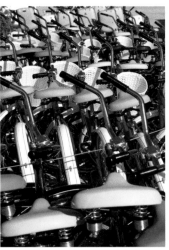

More than 1,000 rental bikes are on the island.

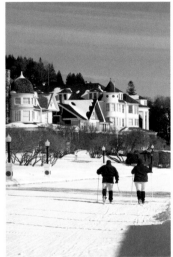

Nordic skiing down Huron Street. There are many excellent trails around the island.

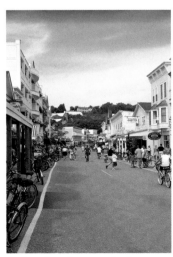

Before the afternoon ferries.

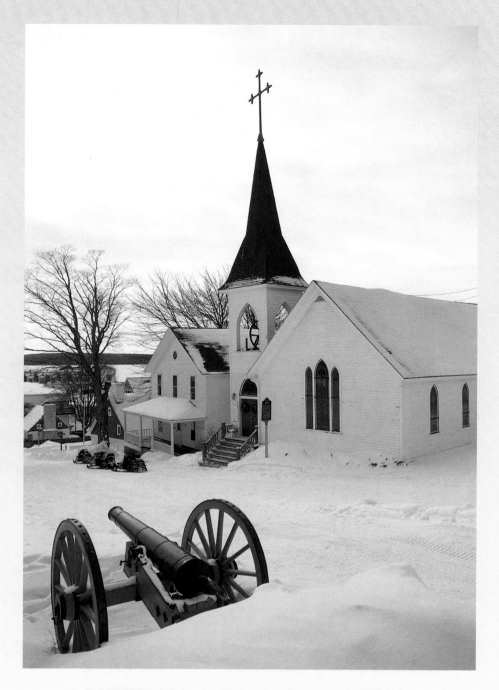

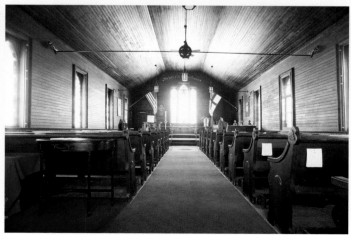

Trinity Church was built in 1882.

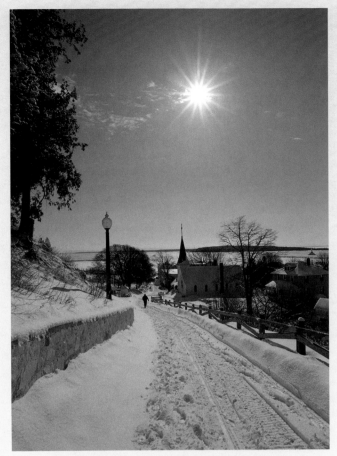

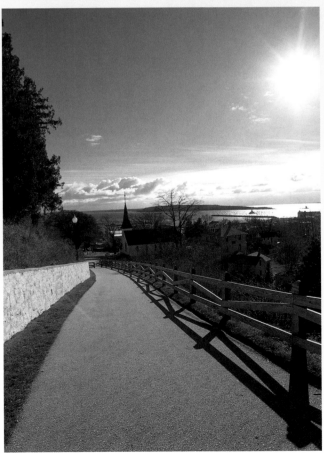

*Fort Street leading down to the Trinity Church
in winter and summer.*

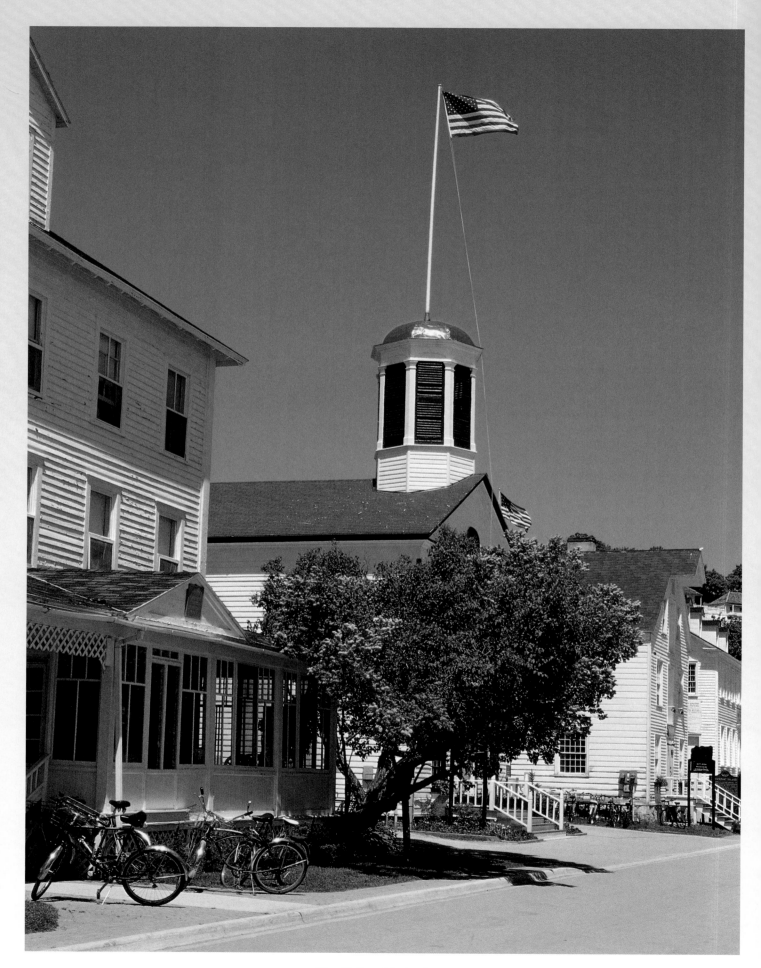

City Hall on Market Street.

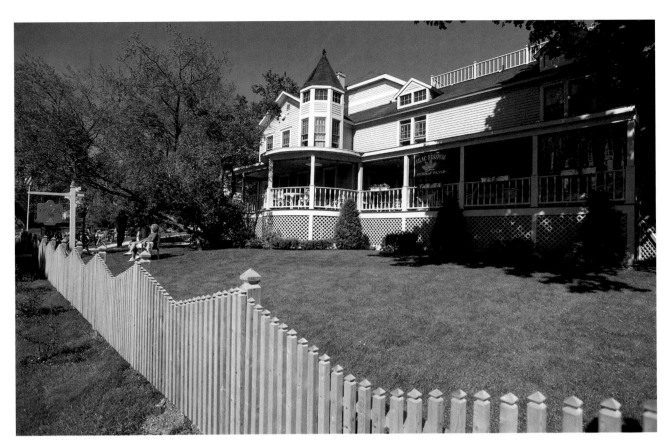

Metivier Inn on Market Street.

Six hundred horses are stabled on the island during the summer season. Consuming 500 tons of hay each summer, the herd is reduced to 20 during winter when feed transportation becomes too expensive.

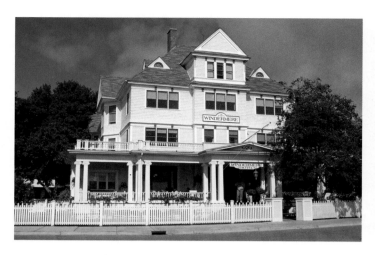

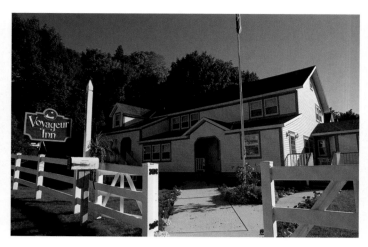

Windermere Hotel across from Biddle's Point.

The Voyageur Inn on Church Street.

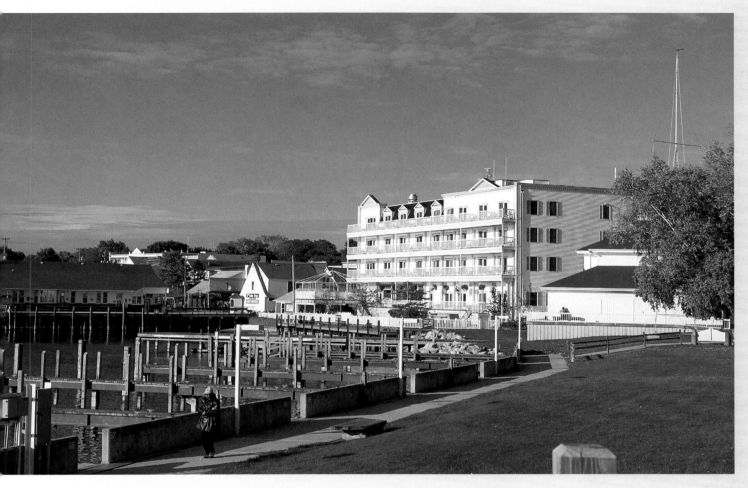

The island marina with the Chippewa Hotel in the background.

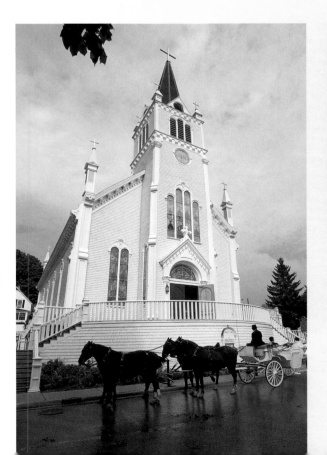

Ste. Anne's Catholic Church. The carriage awaits the bride and groom. Every summer, hundreds of weddings are held on the island.

The wedding carriage on Market Street.

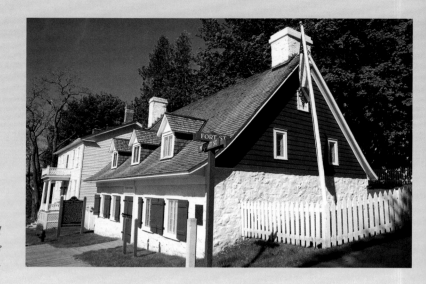

The Beaumont Memorial House and the Geary House on Market Street.

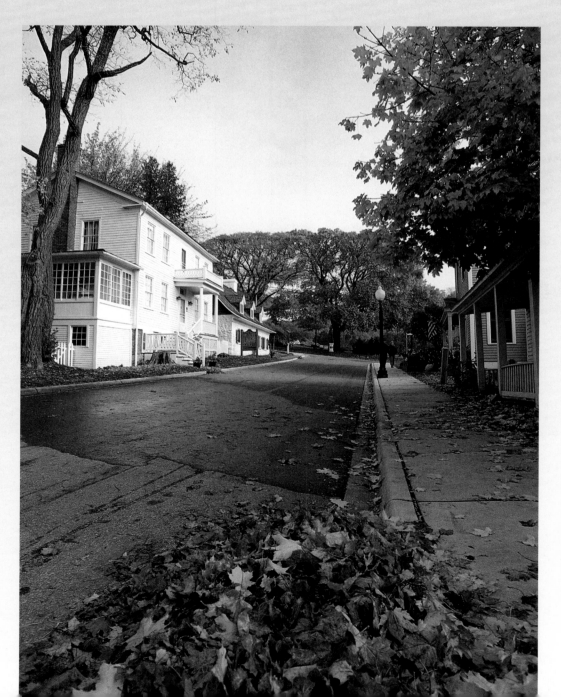

Autumn on Market Street. Geary House and the Beaumont Memorial.

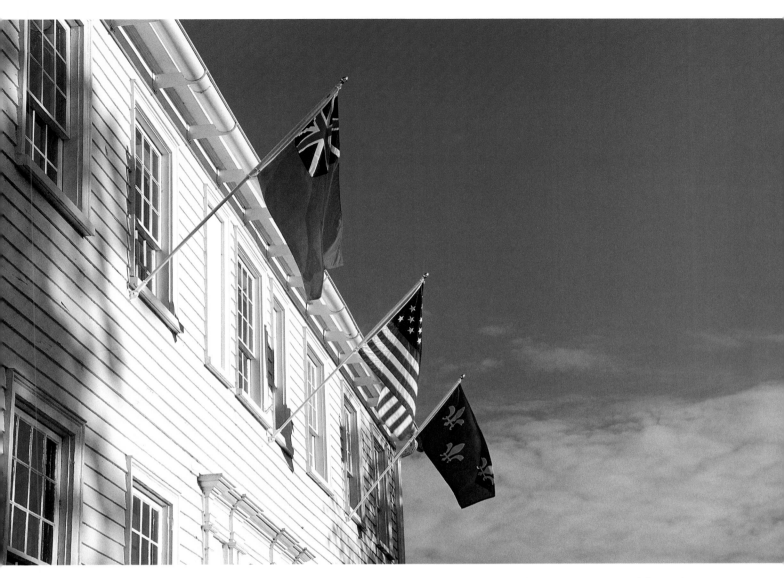

The flags of the Stuart House (1817). Robert Stuart, manager of the northern sector of the North American Fur Company, and his wife, Elizabeth, lived here for twenty years.

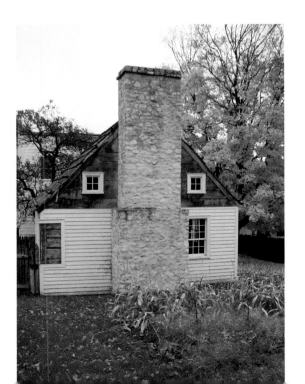

Front and side view of the McGulpin House on Fort Street.

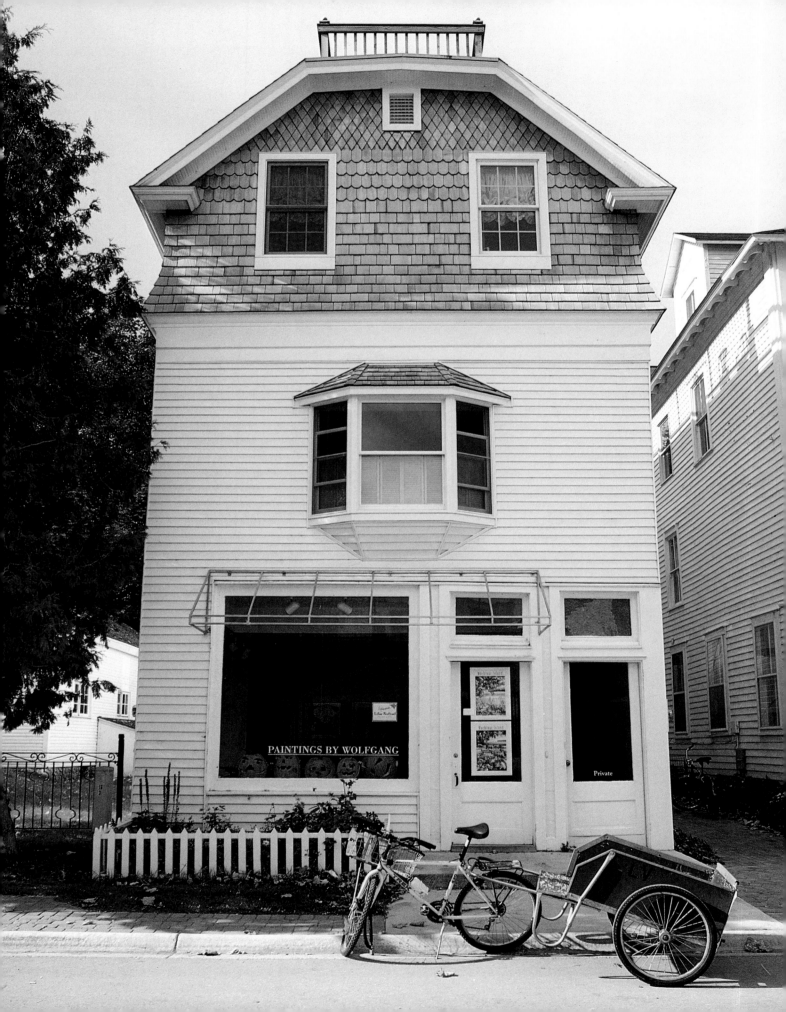

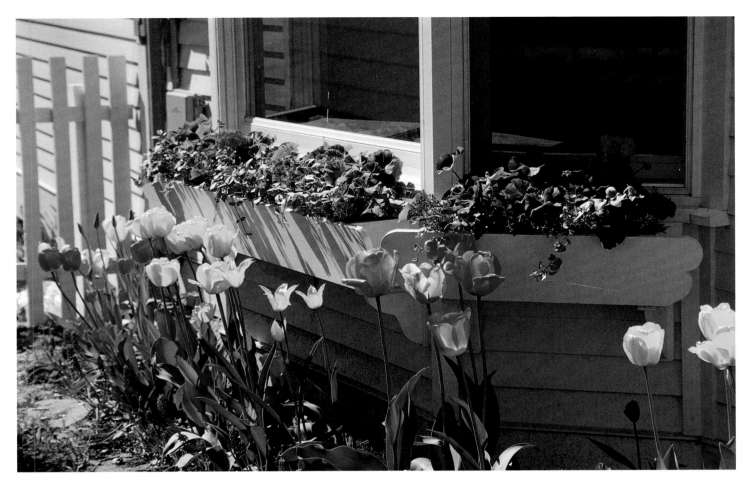

Spring hues on Market Street.

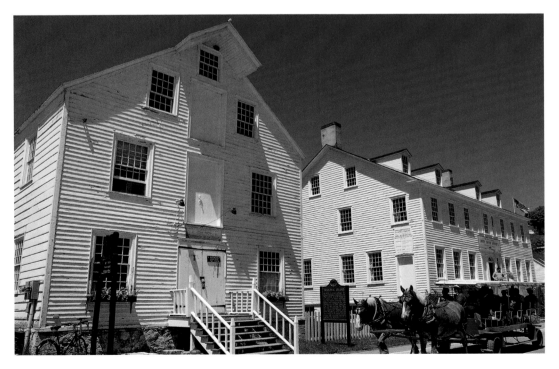

Market Street's Astor Warehouse and Stuart House.

A delivery to Wolfgang's Studio on Market Street.

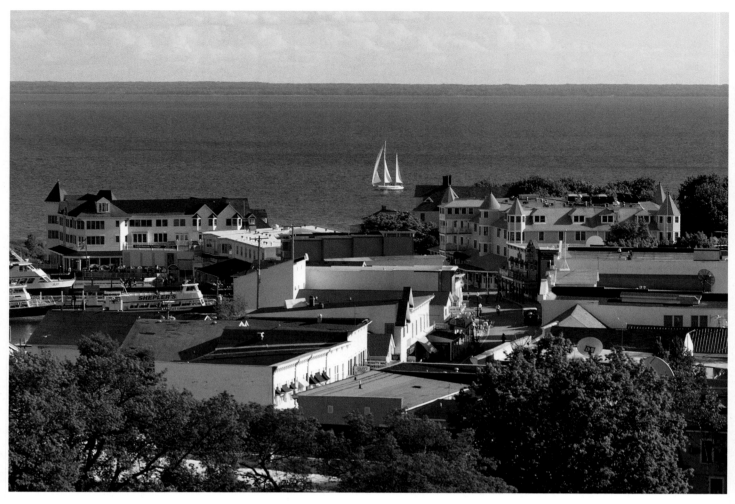

Looking down Huron Street to Windermere Point.
Iroquois Hotel (left) and Lakeview Hotel (right).

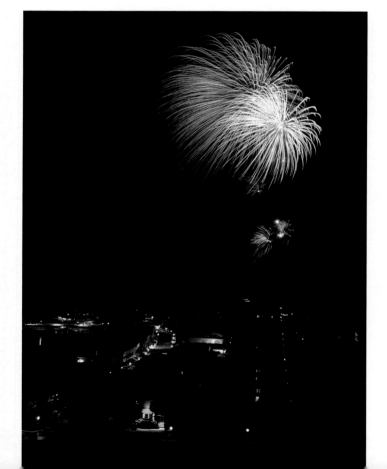

Celebrating the Lilac Festival in June
with fireworks over Windermere Point.

Opposite page:
Ste. Anne's with lilacs in bloom.

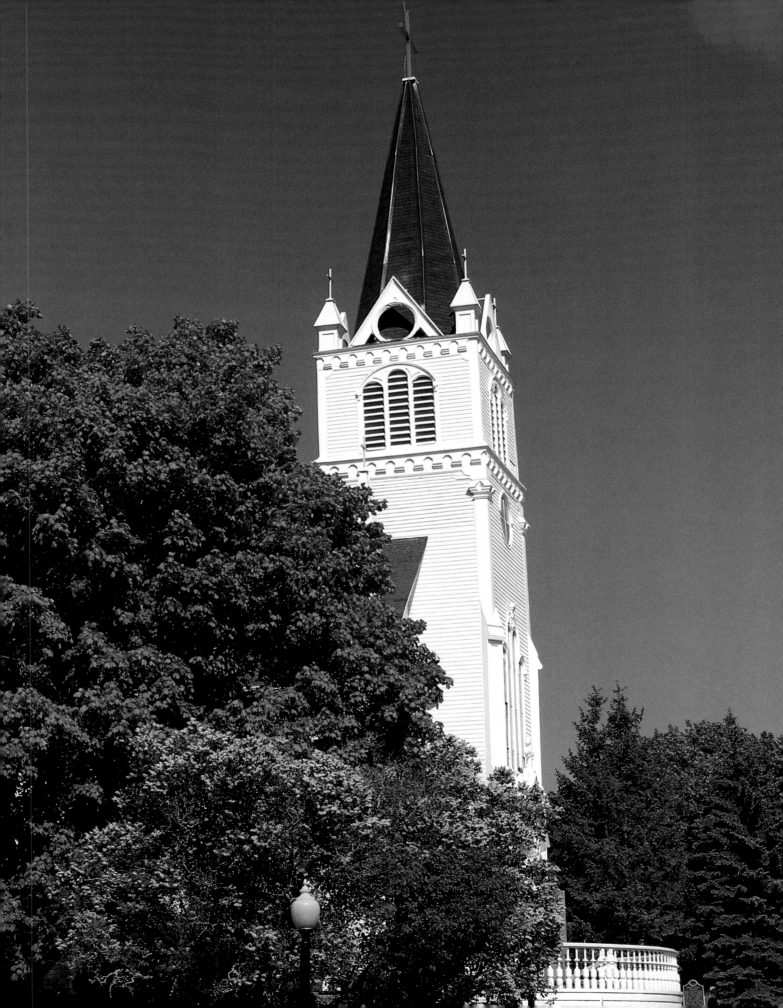

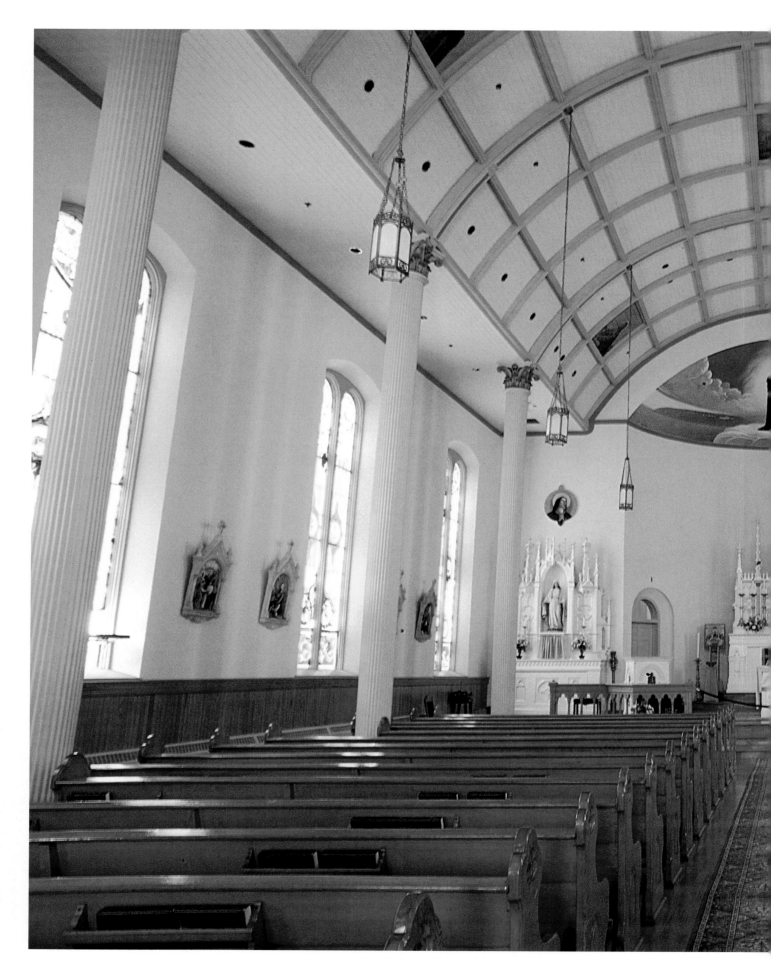

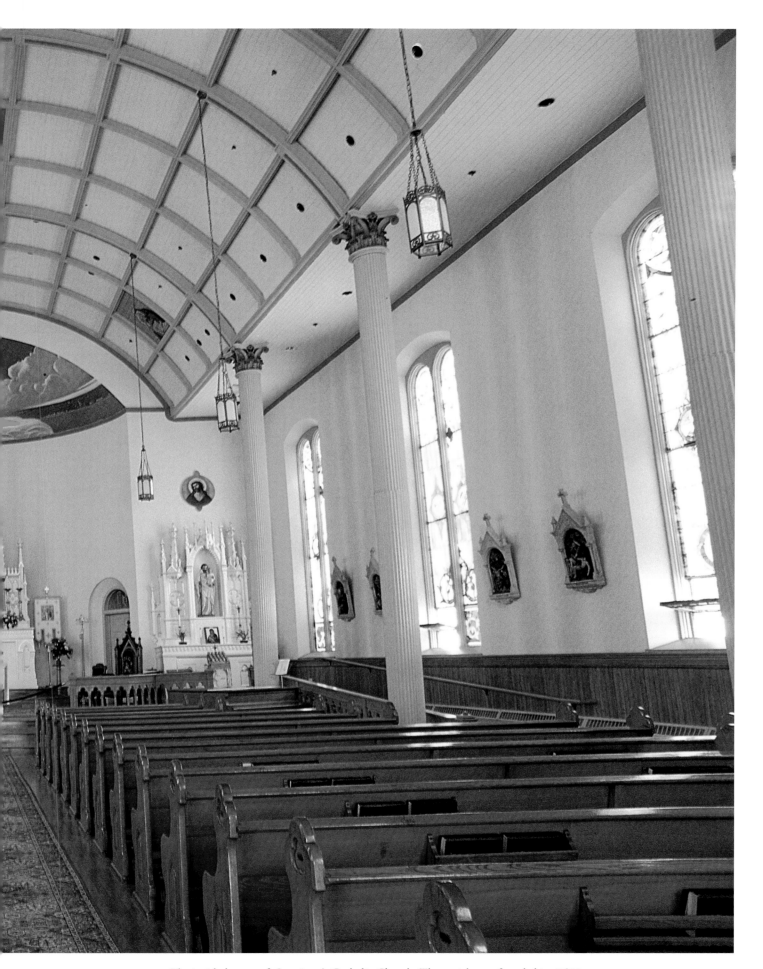

The inside beauty of Ste. Anne's Catholic Church. The parish was founded in 1670.

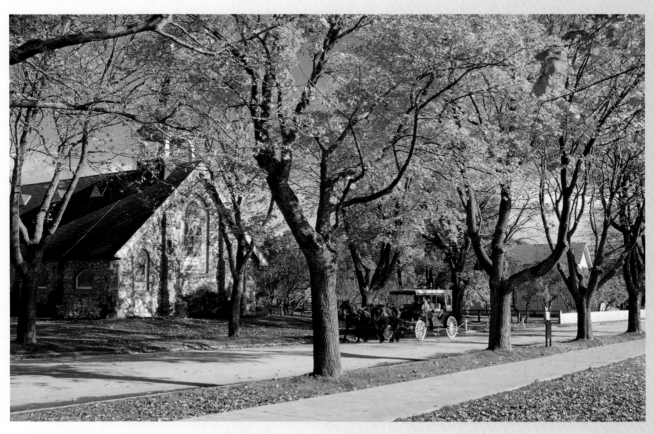

Little Stone Congregational Church on Caddotte Ave. (founded 1896).

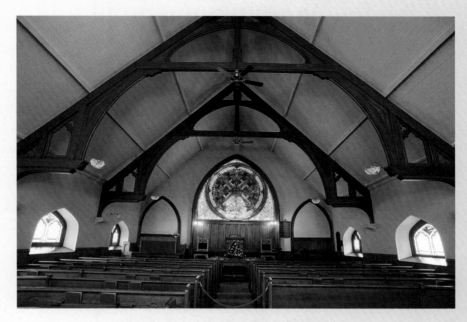

Interior of Little Stone Congregational Church.

A niche on Market Street.

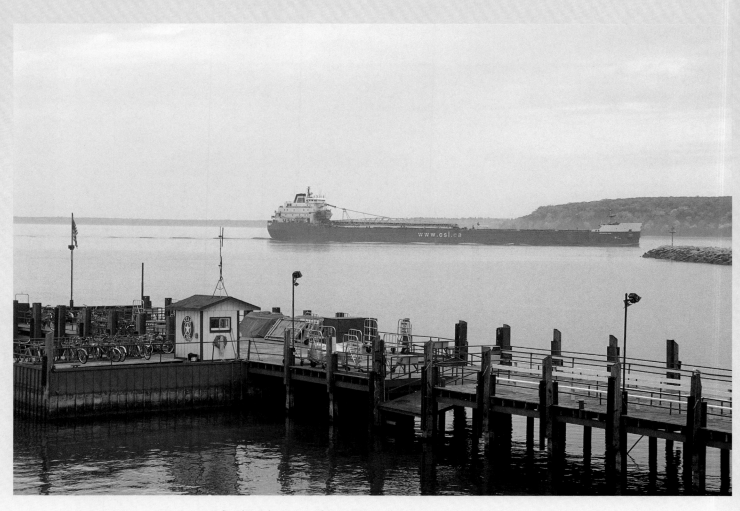

An iron ore freighter that comes from Minnesota's Iron Range passes the Star Line dock.

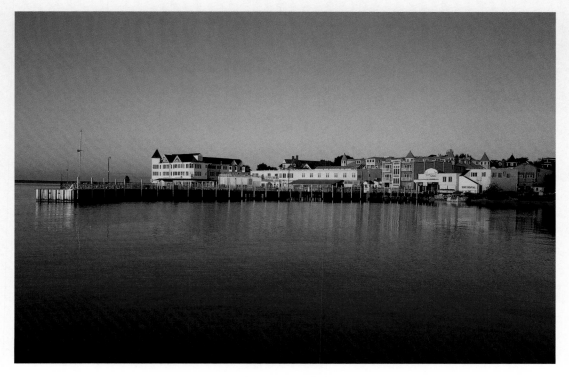

The Star Line dock.

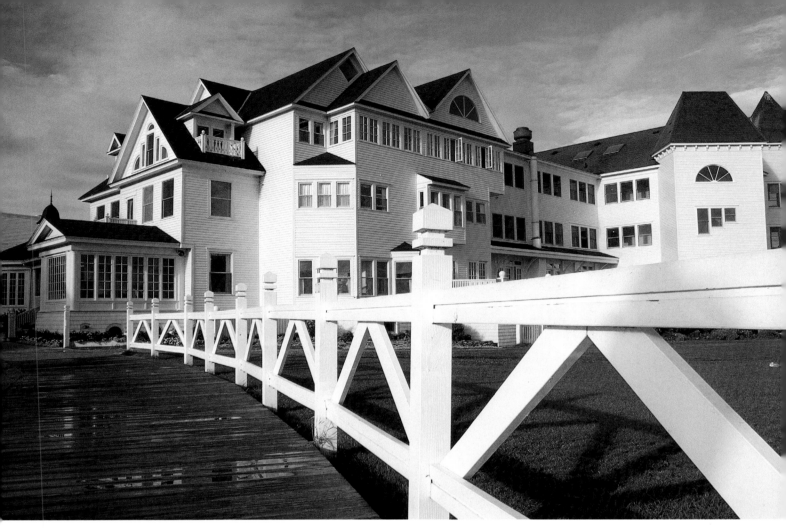

The Iroquois Hotel where the boardwalk begins.

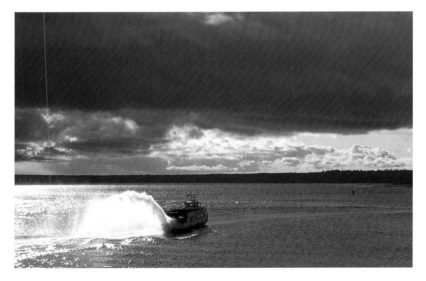

Shepler's ferry heading toward the Round Island Passage.

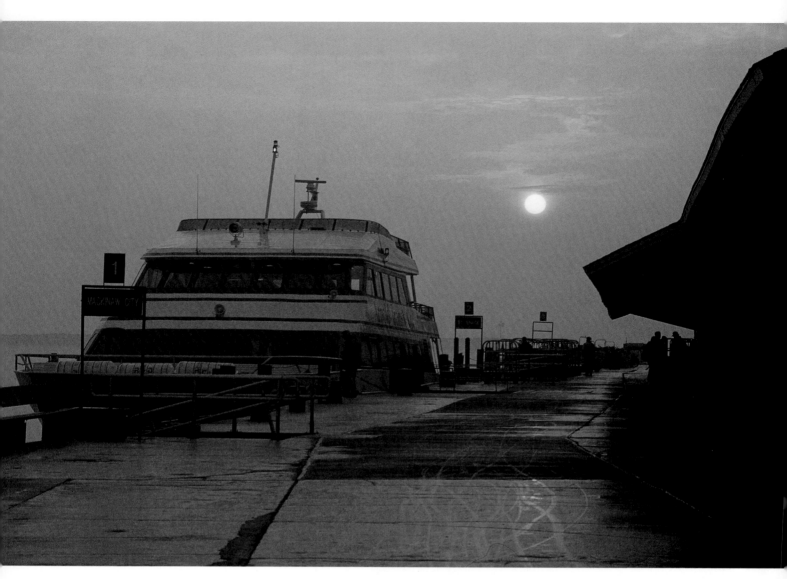

The Arnold dock at sunrise.

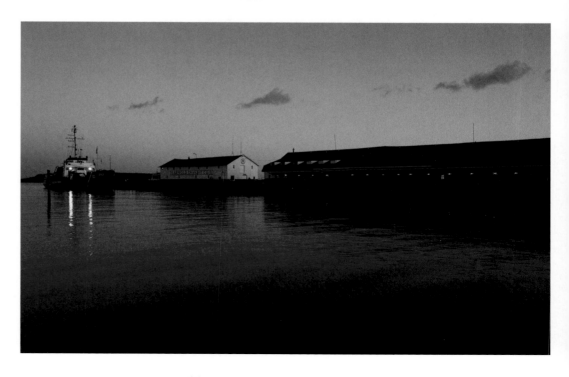

*Coast Guard cutter
at the Arnold dock.*

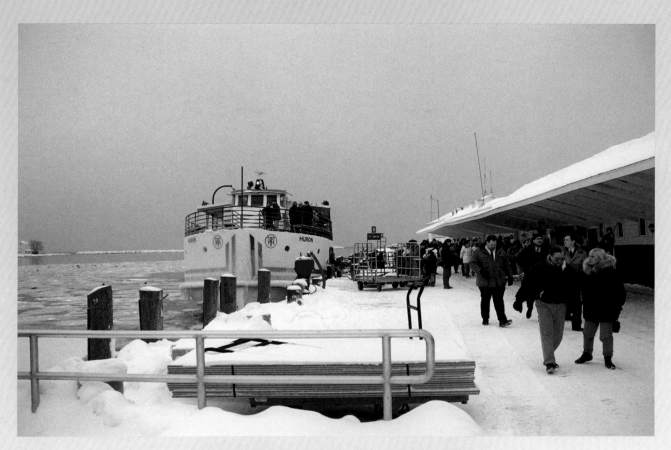

A December ferry breaks ice flows on its passage from St. Ignace.

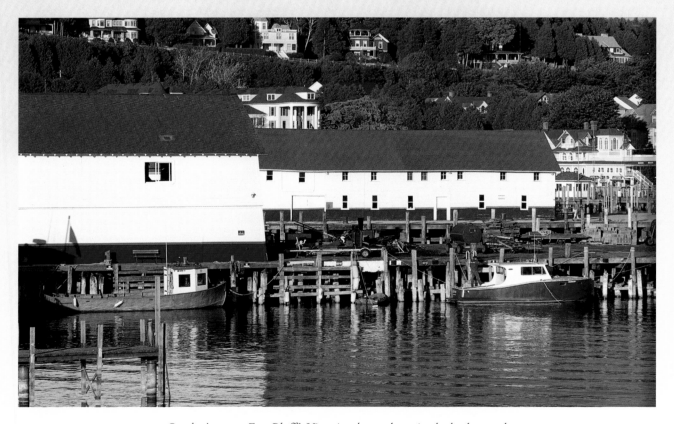

October's peace. East Bluff's Victorian homes loom in the background.

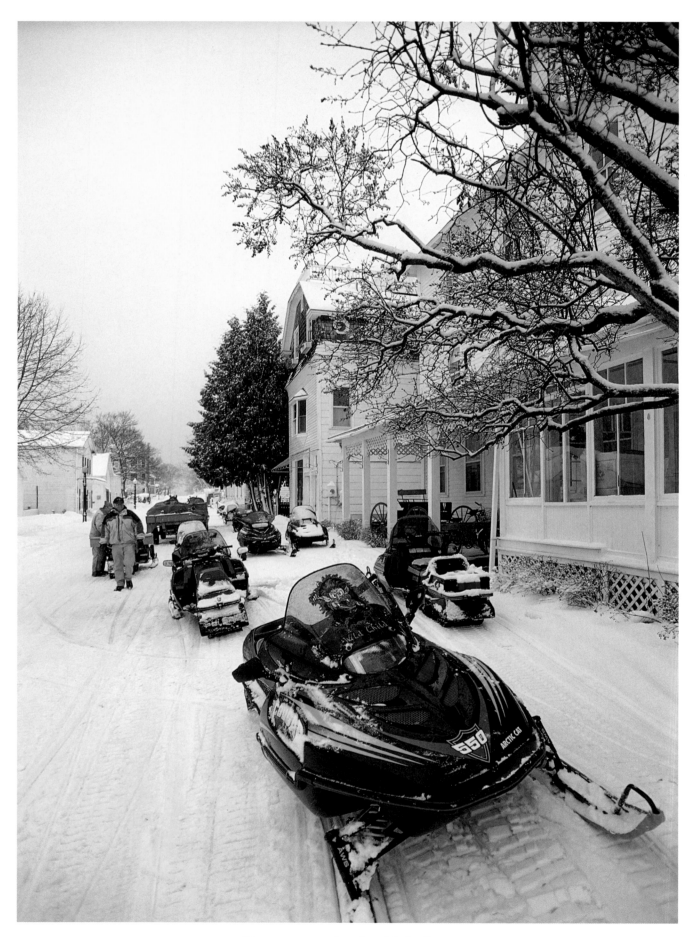

Winter transportation along Market Street.

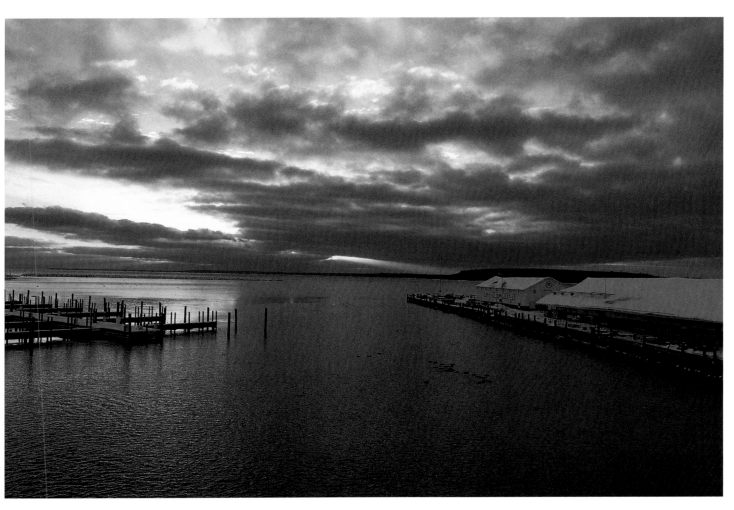

Early in December on Haldimand Bay, a majestic mix of sun and clouds awaits the arrival of the first ferry.

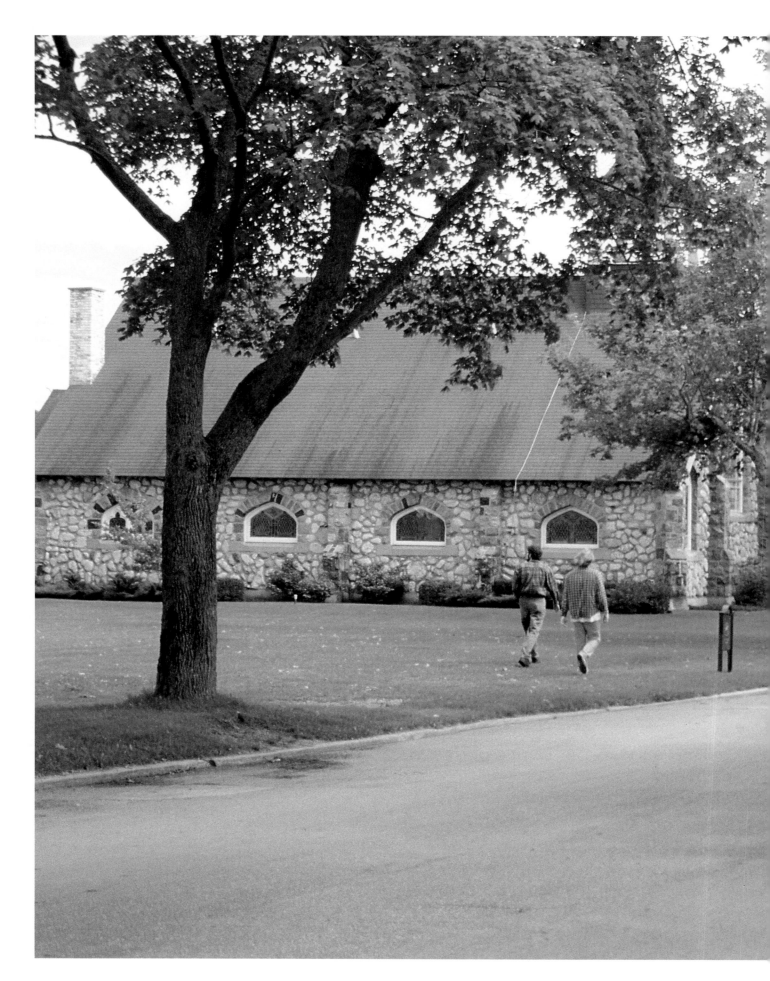

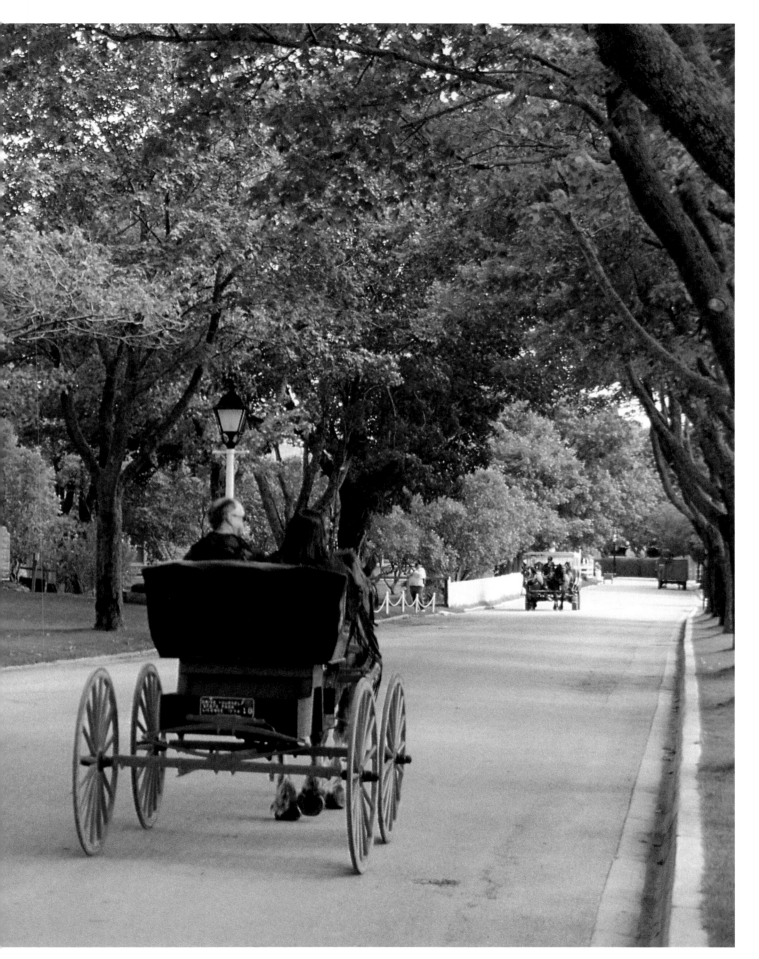

A "drive yourself" carriage heading down Cadotte Avenue past the Little Stone Church.

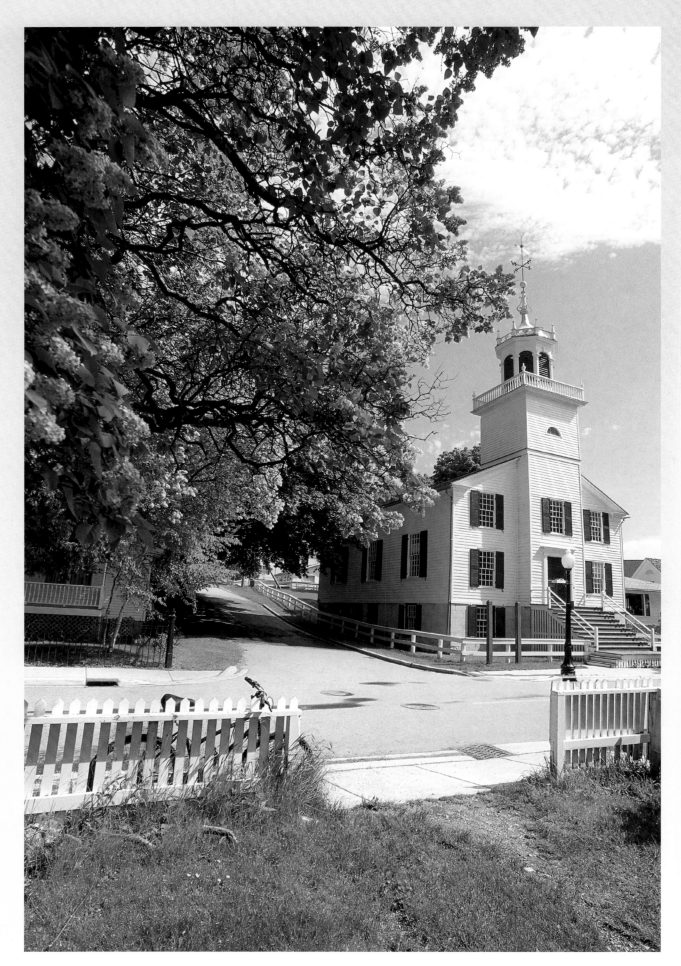

Mission Church on Huron Street (founded 1830).

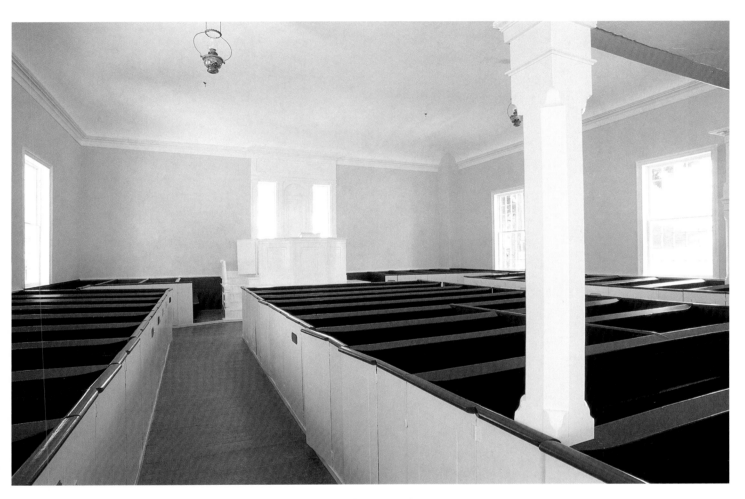

Interior of Mission Church.

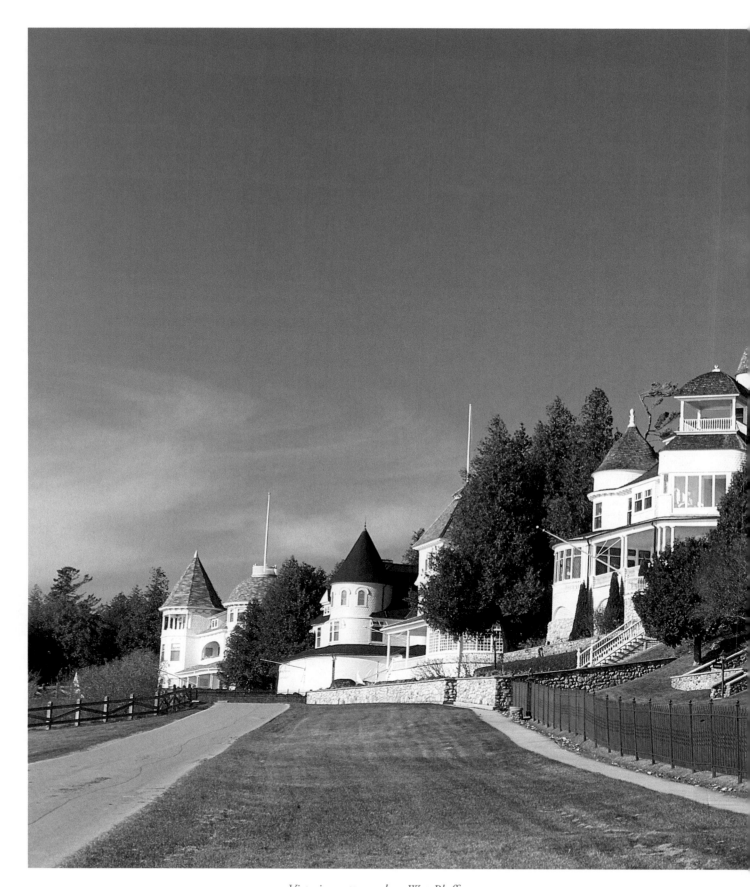

Victorian cottages along West Bluff.

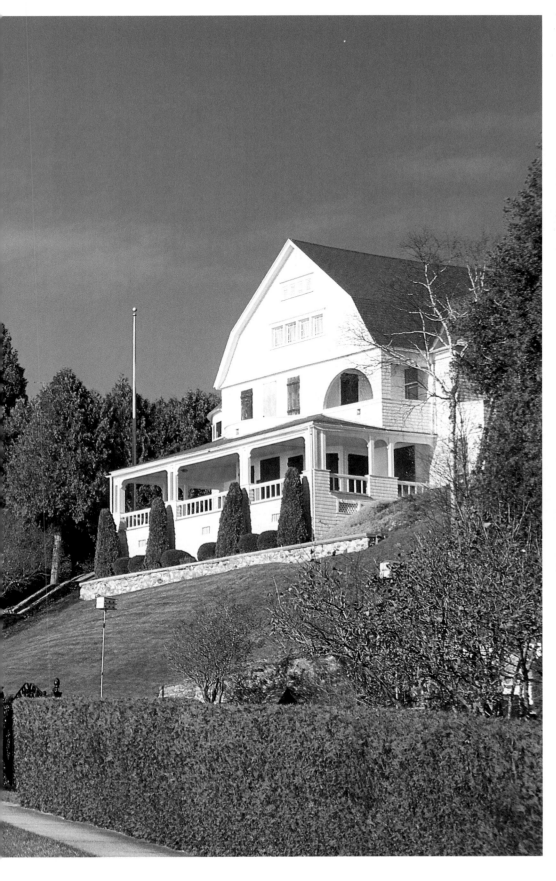

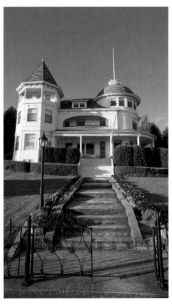

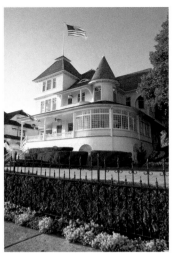

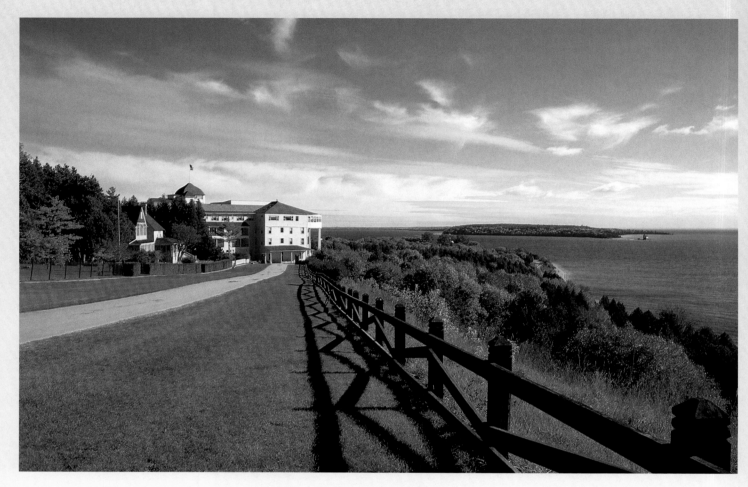

Along the West Bluff toward the Grand.

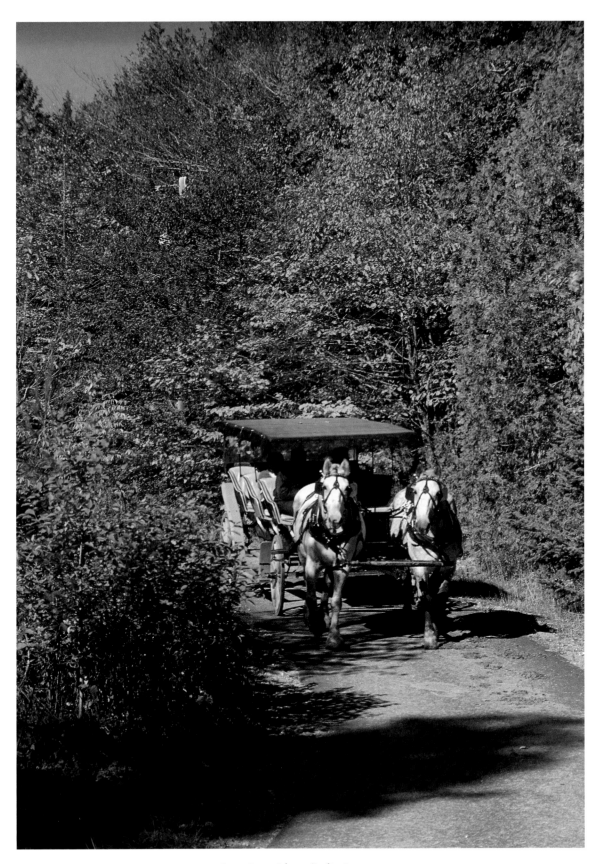

A carriage ride on Leslie Avenue.

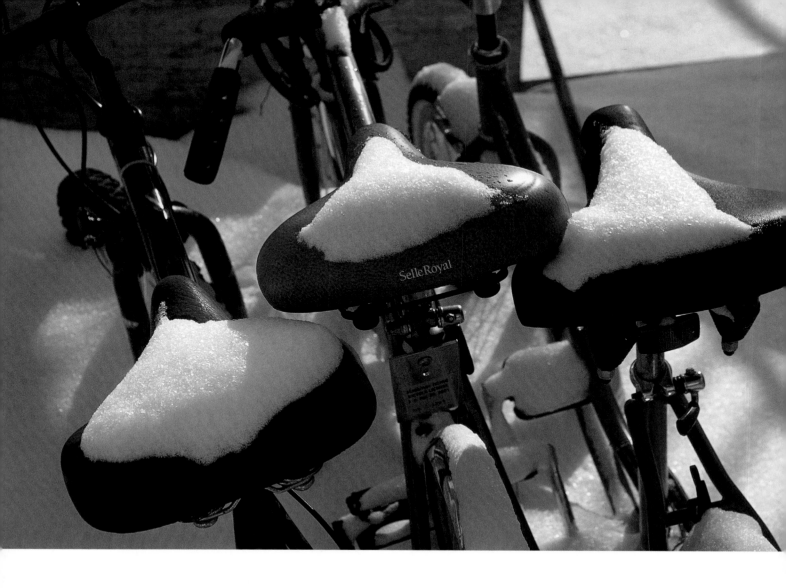

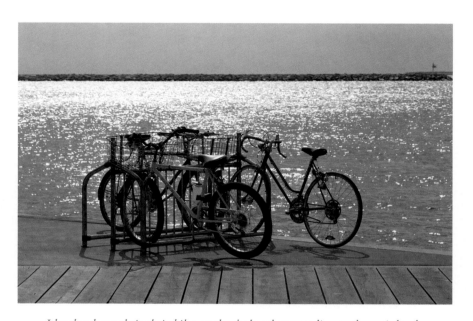

Islanders leave their their bikes at the docks when traveling to the mainland.

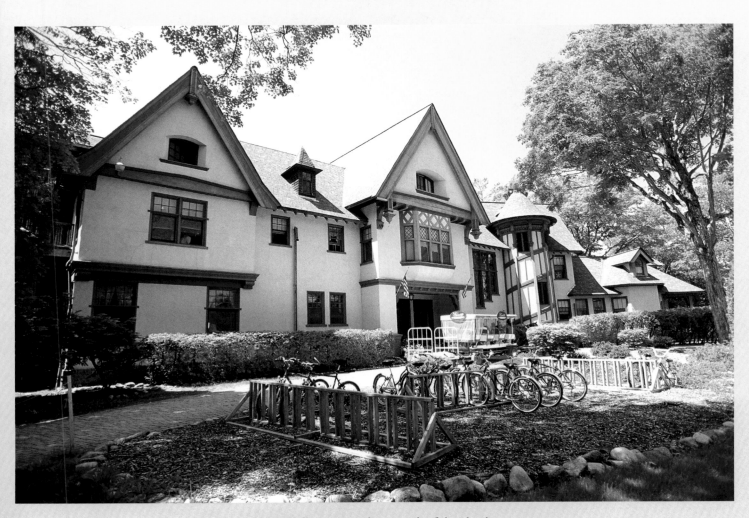

Stonecliffe Resort on the west side of the island.

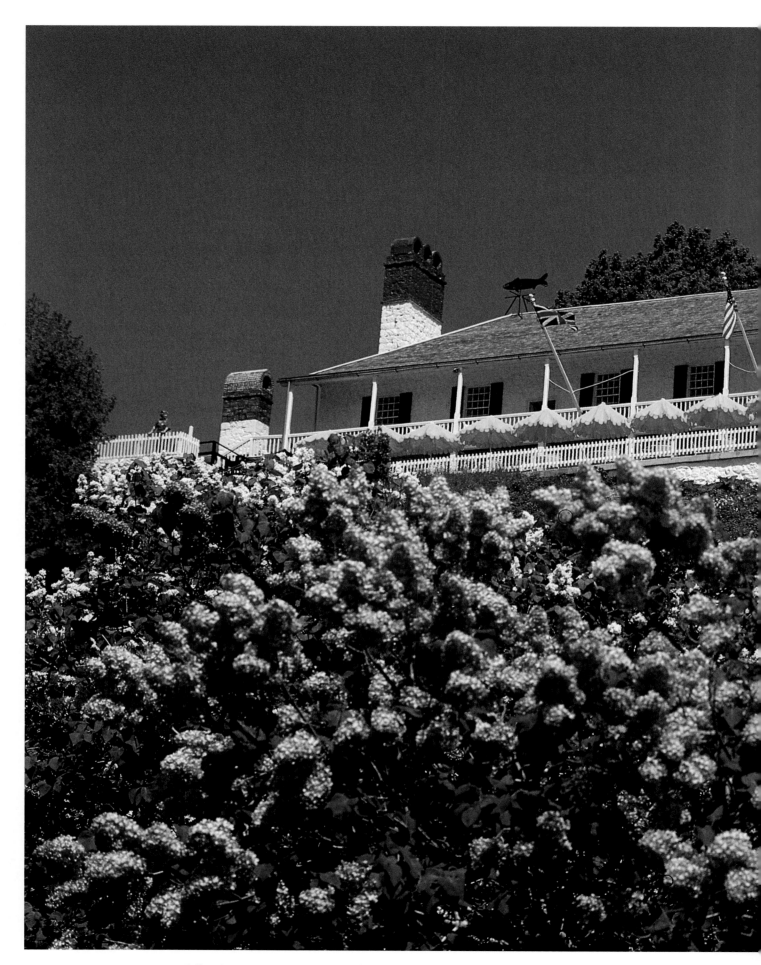

Officers' stone quarters on Fort Mackinac's stone wall. The tea room occupies the lower level.

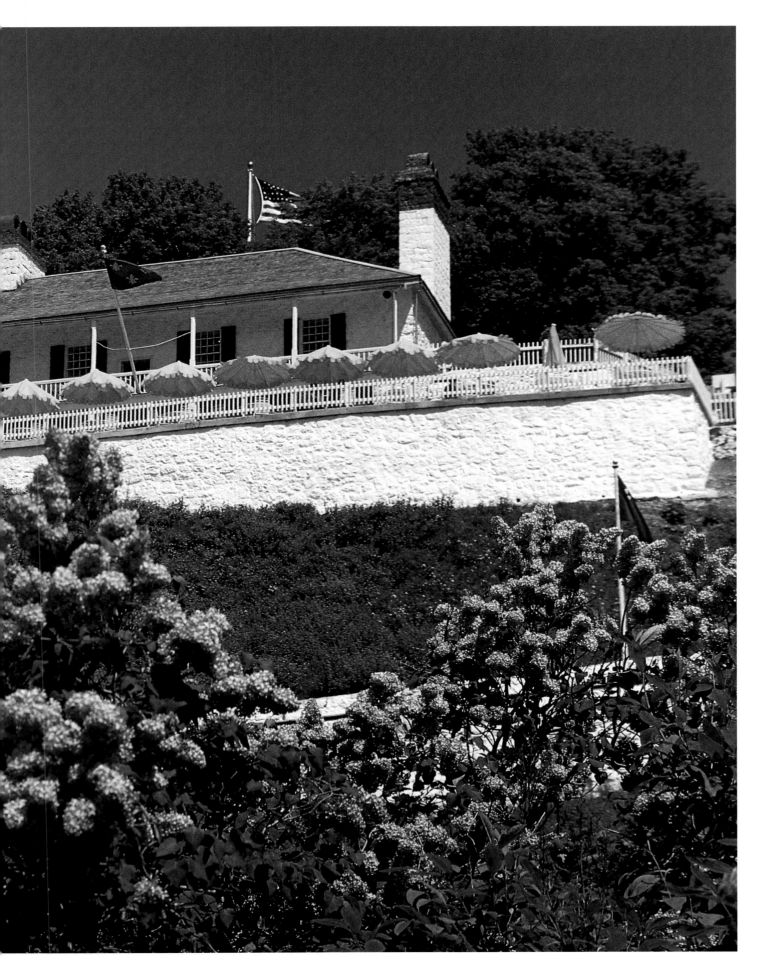

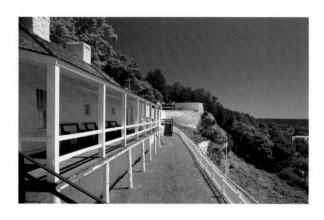

The porch of the officers' quarters.

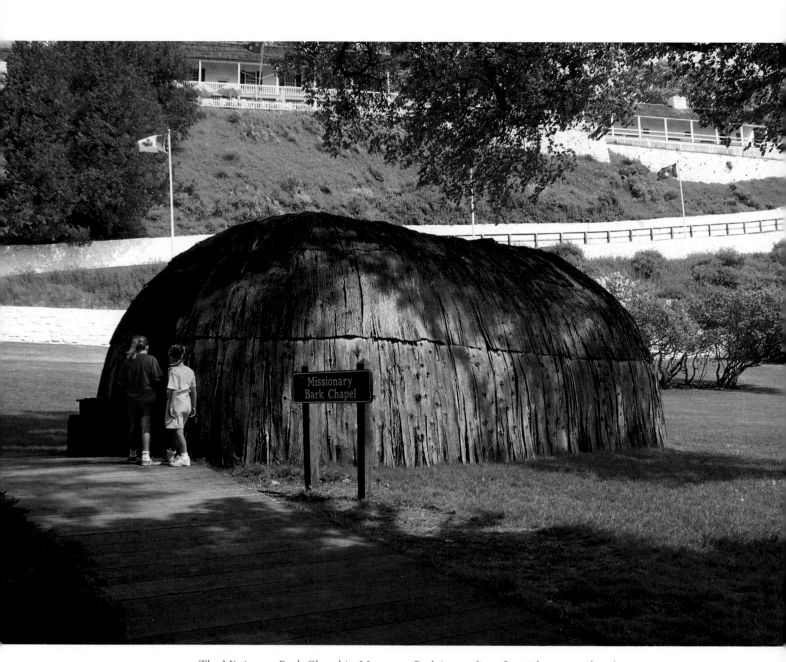

The Missionary Bark Chapel in Marquette Park is a replica of a 17th century chapel.

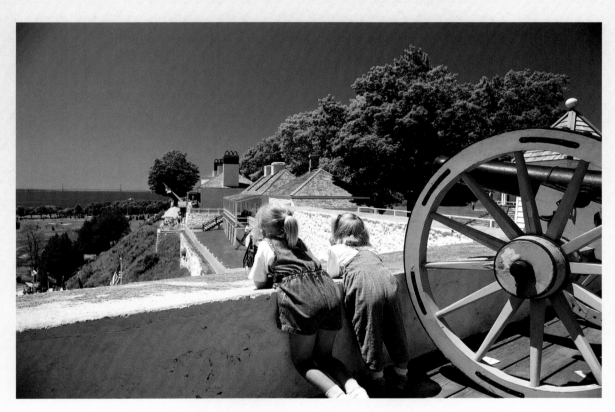

Enjoying the view looking toward the Straits of Mackinac.

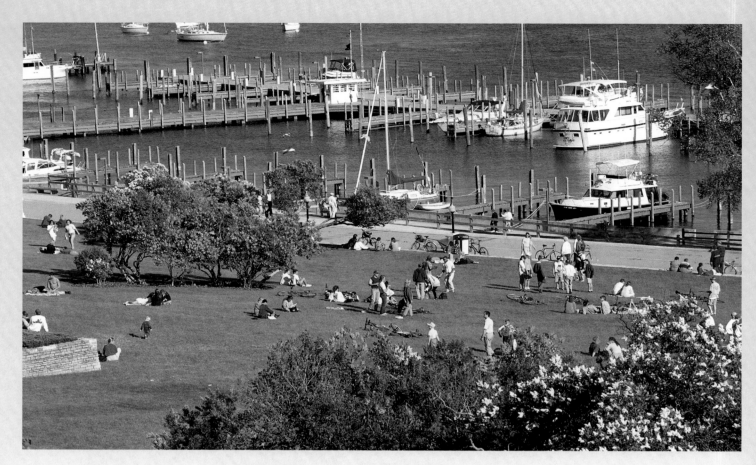

People gather at Marquette Park during the Lilac Festival.

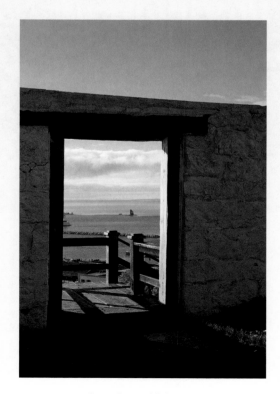

Peering through an old doorway at Fort Mackinac to Haldimand Bay.

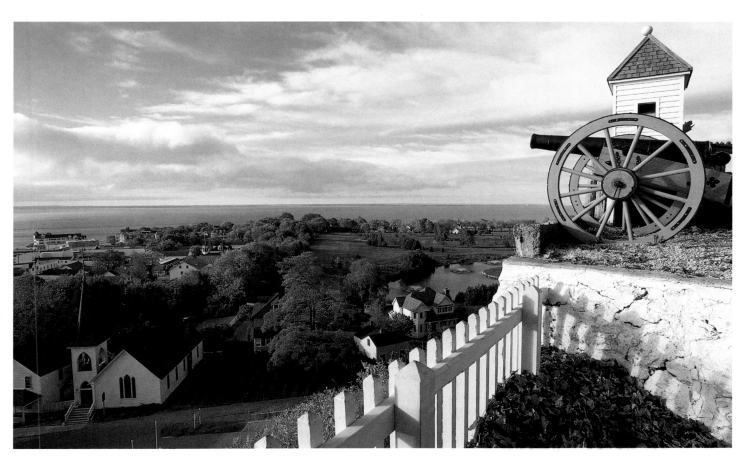

Overlooking the Trinity Lutheran Church on Fort Street and Hank's Pond to the right.

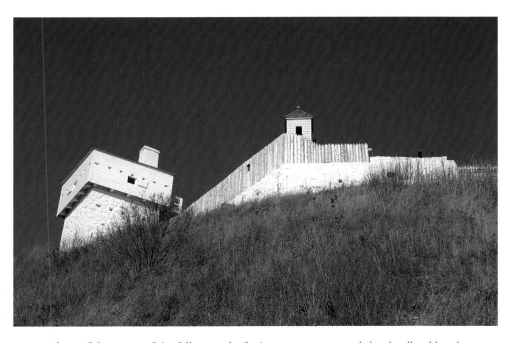

A beautiful contrast of the fall grass, the fort's western corner and the cloudless blue sky.

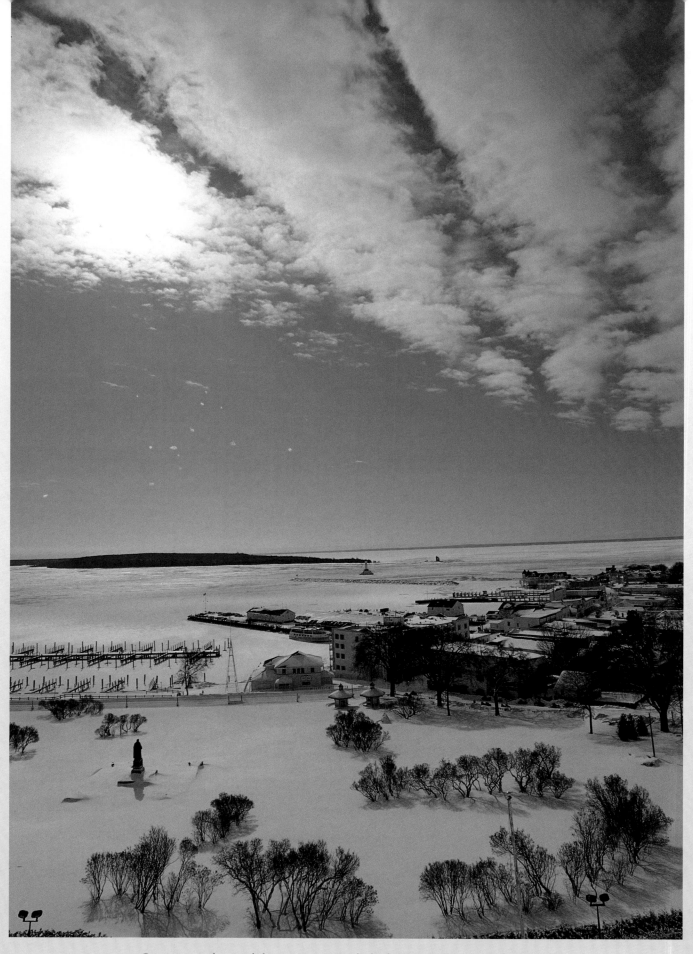

Open to snowshoes and skis via Huron Road, the fort's wall offers unparalleled vistas.

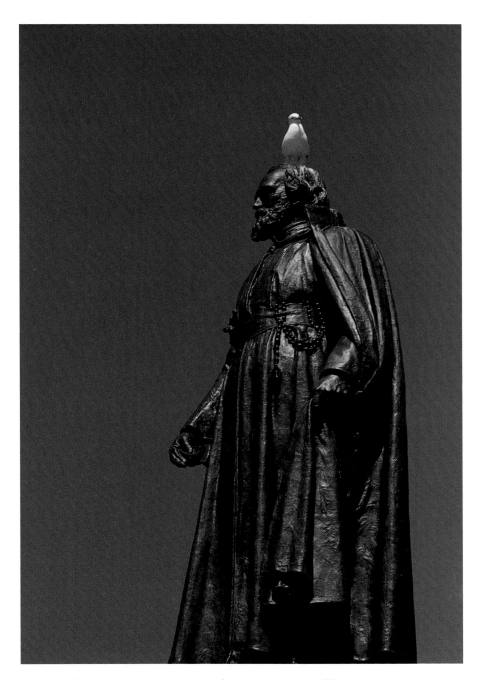

*Father Marquette Statue. As the story goes, Peter White, a prominent
citizen of the city of Marquette, commissioned statues of Father Marquette
for Marquette and a second one for Mackinac Island. Since the artist was unable to find
a likeness of Father Marquette, White boldly suggested that he be the model since he
commissioned the artwork. So really, it's the Peter White Statue....shhhh.*

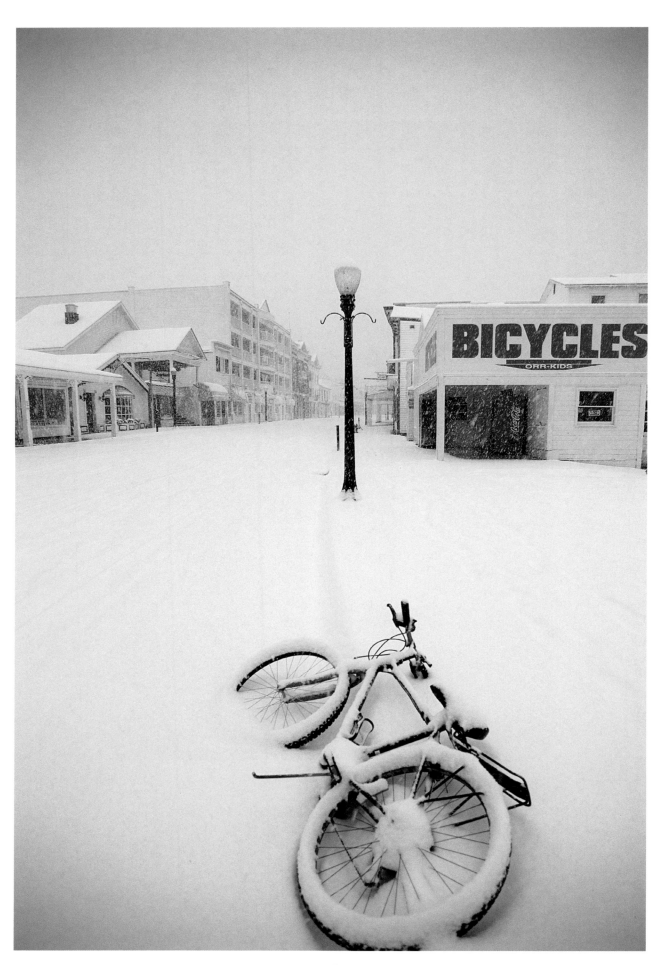

An unexpected snow storm.

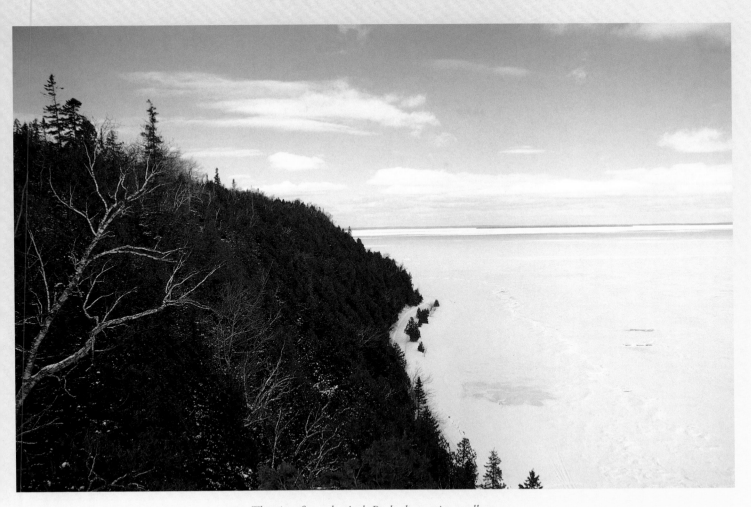

The view from the Arch Rock observation walkway.

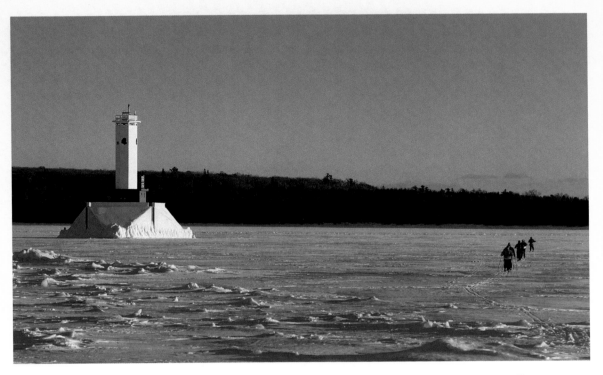

A dangerous trek to Round Island. Unpredictable currents and the icebreaker Mackinaw's *efforts make skiing unwise. The harbor light marks the passage.*

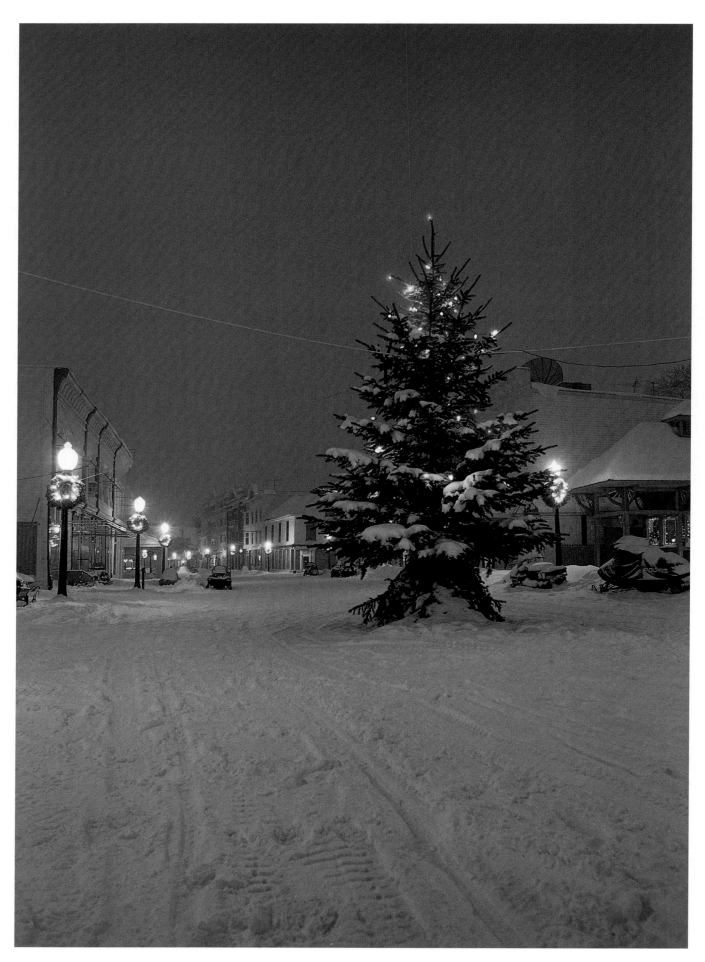

The community Christmas tree in front of the tourism booth on Huron Street.

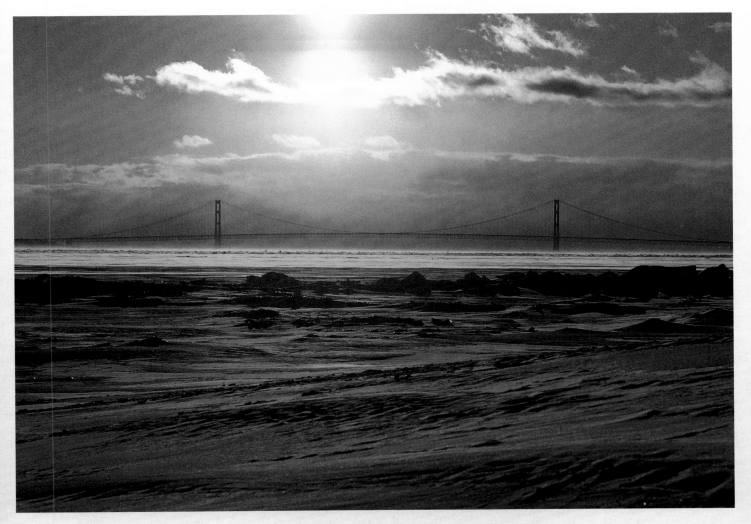

The desolate frozen straits in January.

Following page:
*The French established the parish as "Ste Anne's." The
cemetery was moved to the interior location in 1837.
The American version of "St. Ann's" was used on the
gates when they were constructed in 1924.*

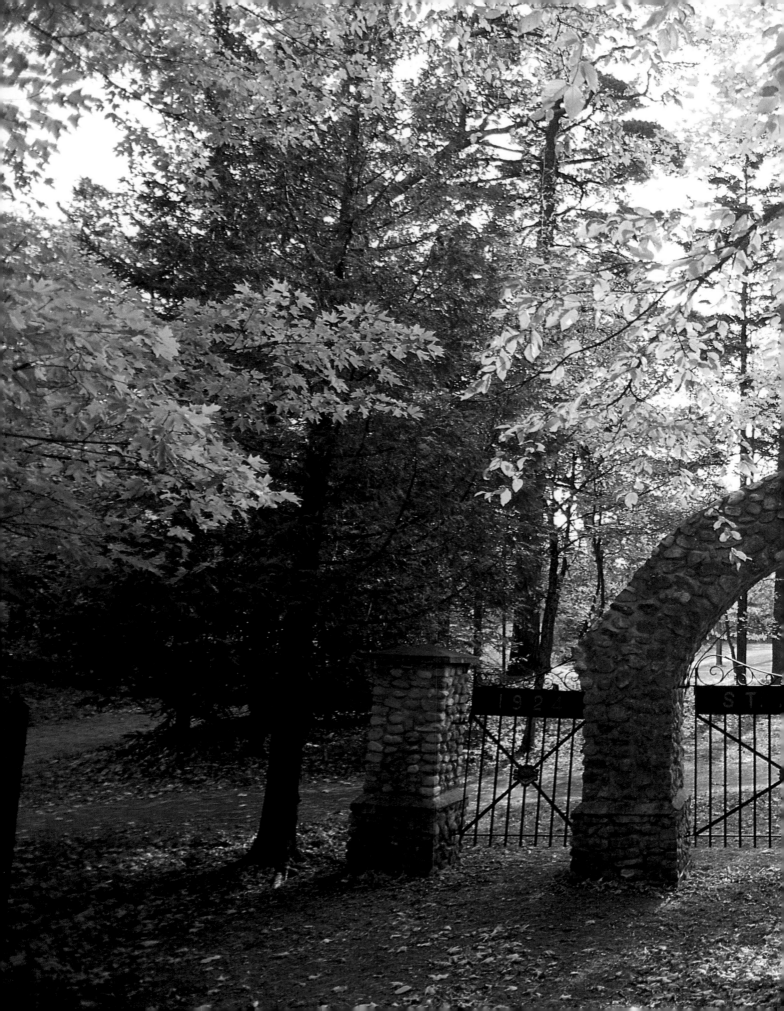

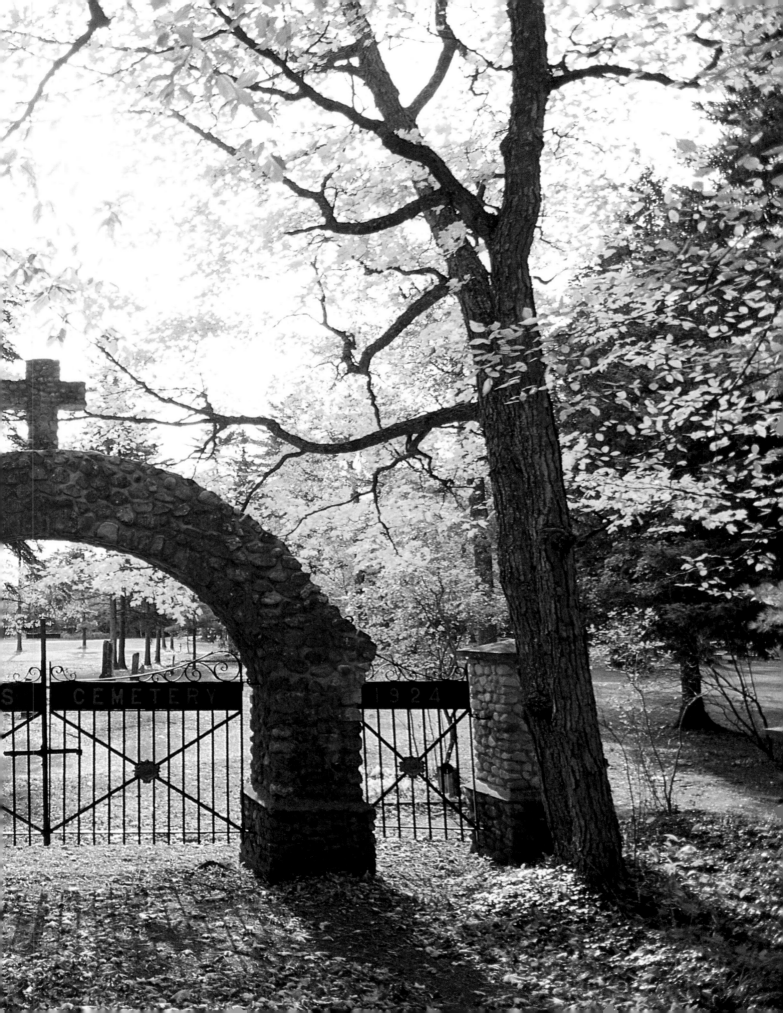

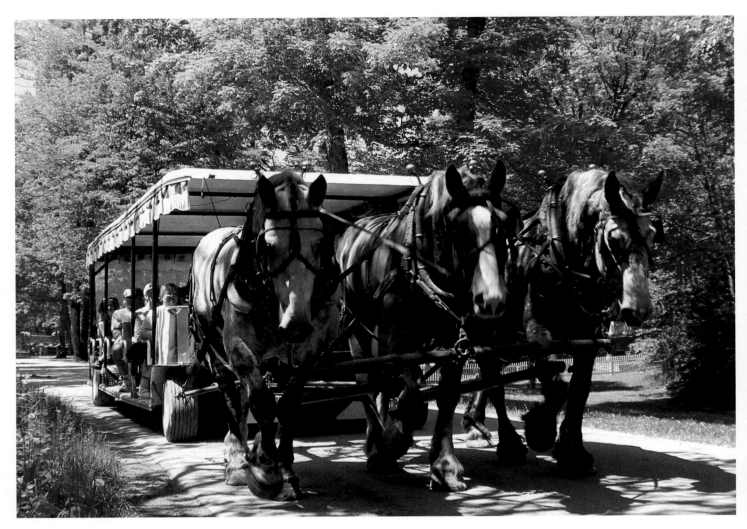

A carriage tour along Garrison Road between the Post and Catholic cemeteries.

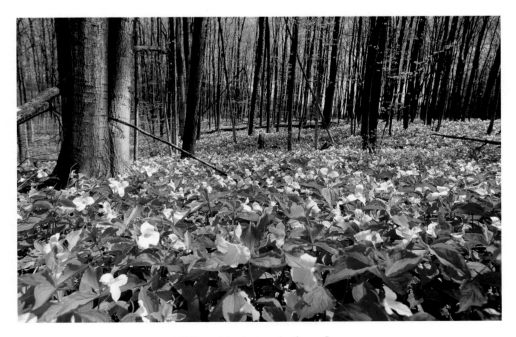

Trillium blanketing the forest floor.

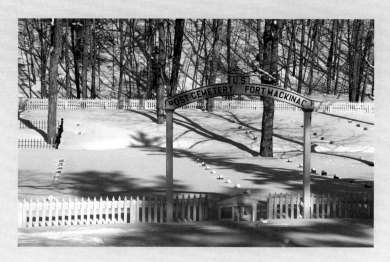

The Post Cemetery.

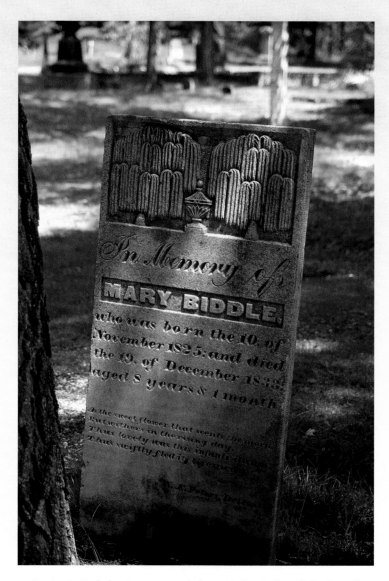

St. Ann's Catholic Cemetery and the symbols of a hard life abound.

Fort Holmes.

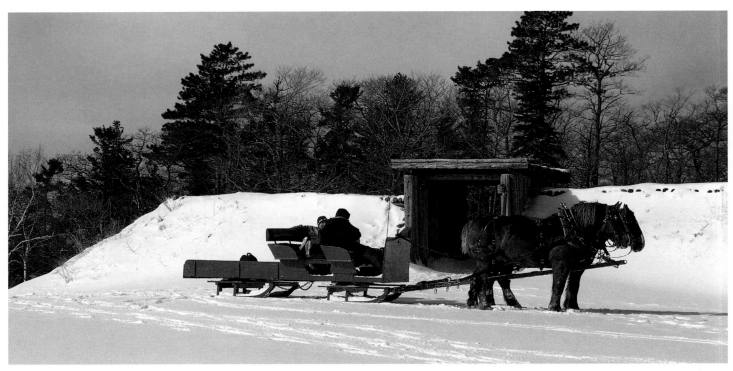

Fort Holmes draped in snow.

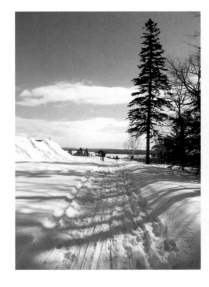

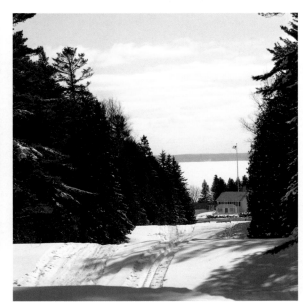

The Rifle Range at Fort Holmes.

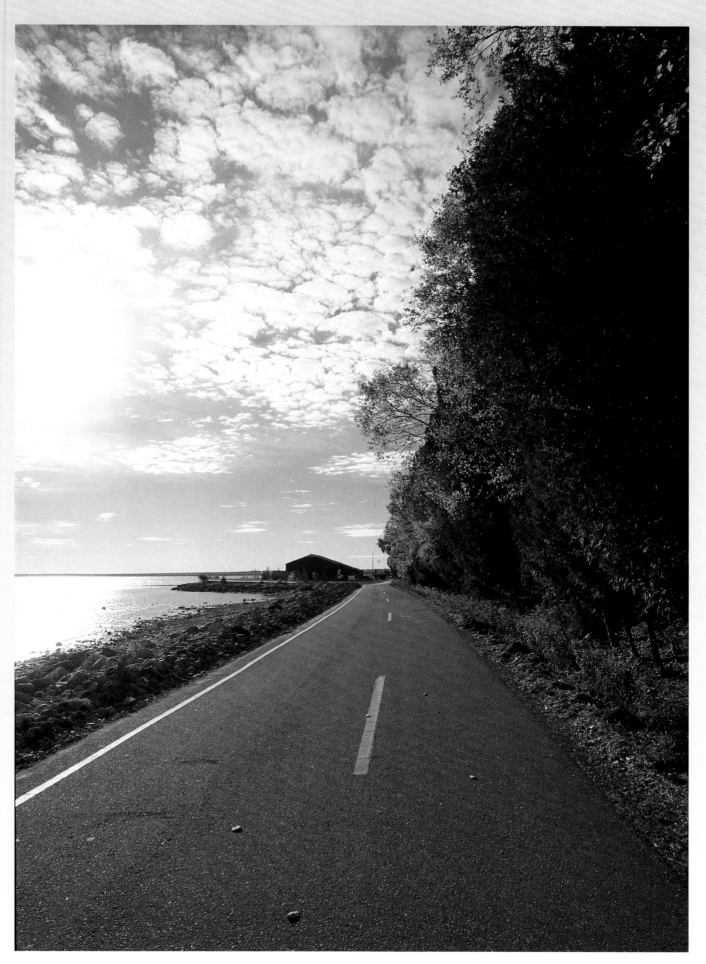

Lakeshore Road with the water filtration plant on the left.

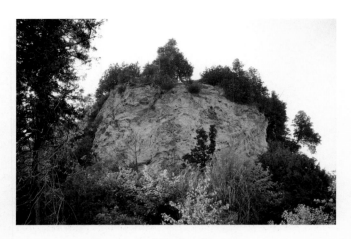

Robinson's Folly.

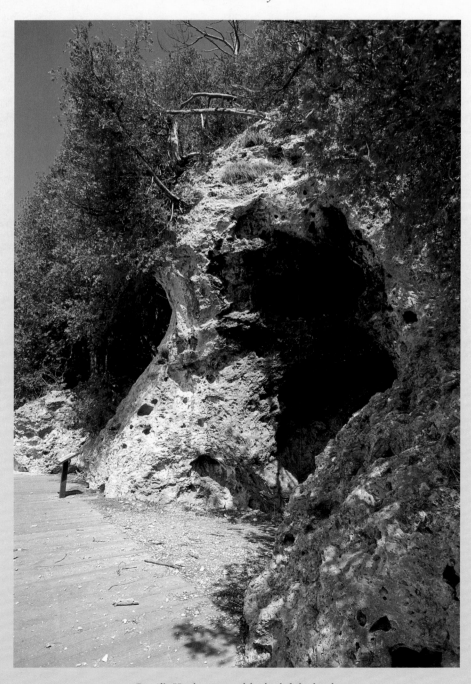

Devil's Kitchen carved by high lake levels.

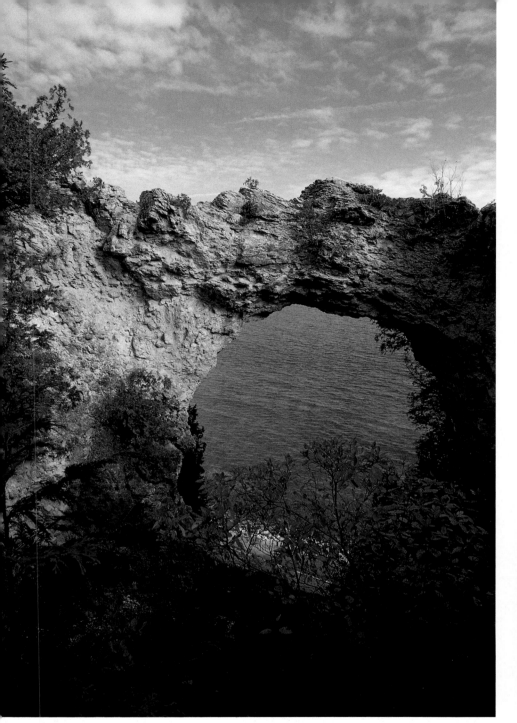

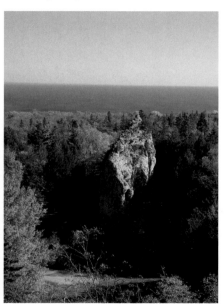

Skull Cave, said to be full of bones, was a refuge for Alexander Henry during the Indian uprising at Fort Michilimackinac.

Arch Rock stands 150 feet above Lake Huron. It is nearly fifty feet wide. According to Indian lore, the Great Spirit entered the island here with the rising sun.

Sugarloaf is made of brecciated limestone. The spire stands as a testament to the weather's vicious mechanisms of erosion which carved it from the remaining cliffs.

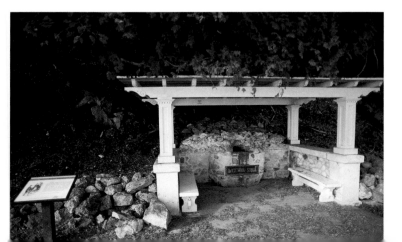

Edwin O. Wood donated funds to create a respite at a springs along Lakeshore Road near Arch Rock. Named for his son Dwight, who unsuccessfully attempted to save his brother's life, the monument reminds us of how fragile life can be.

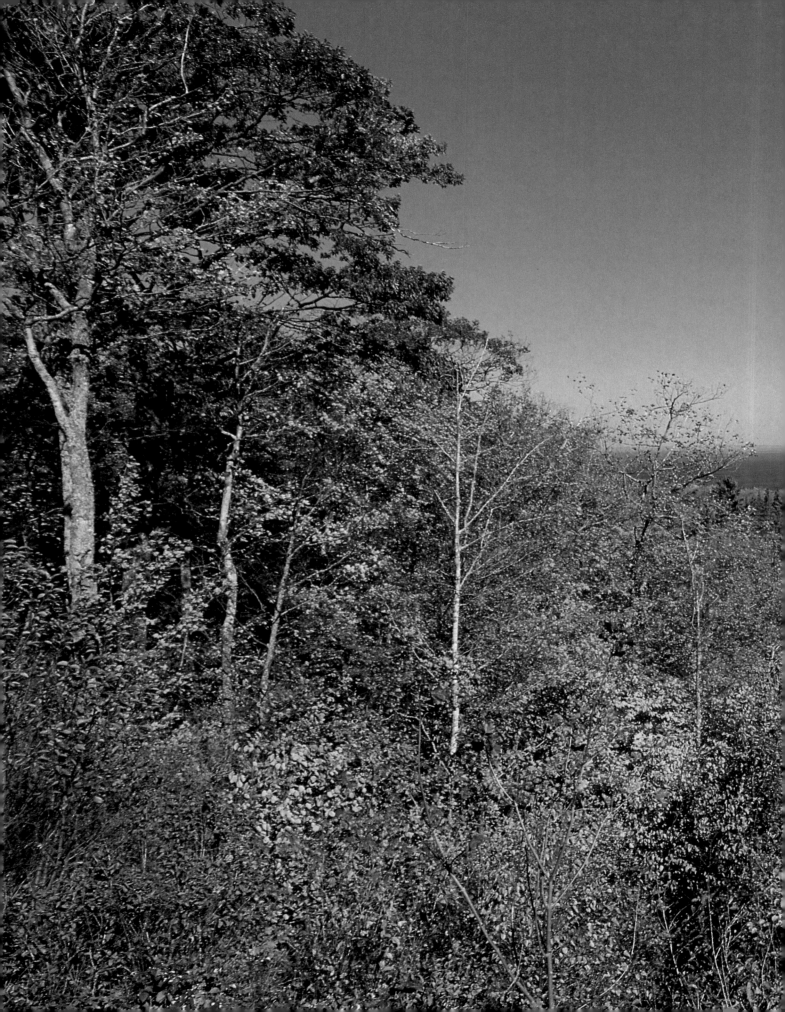

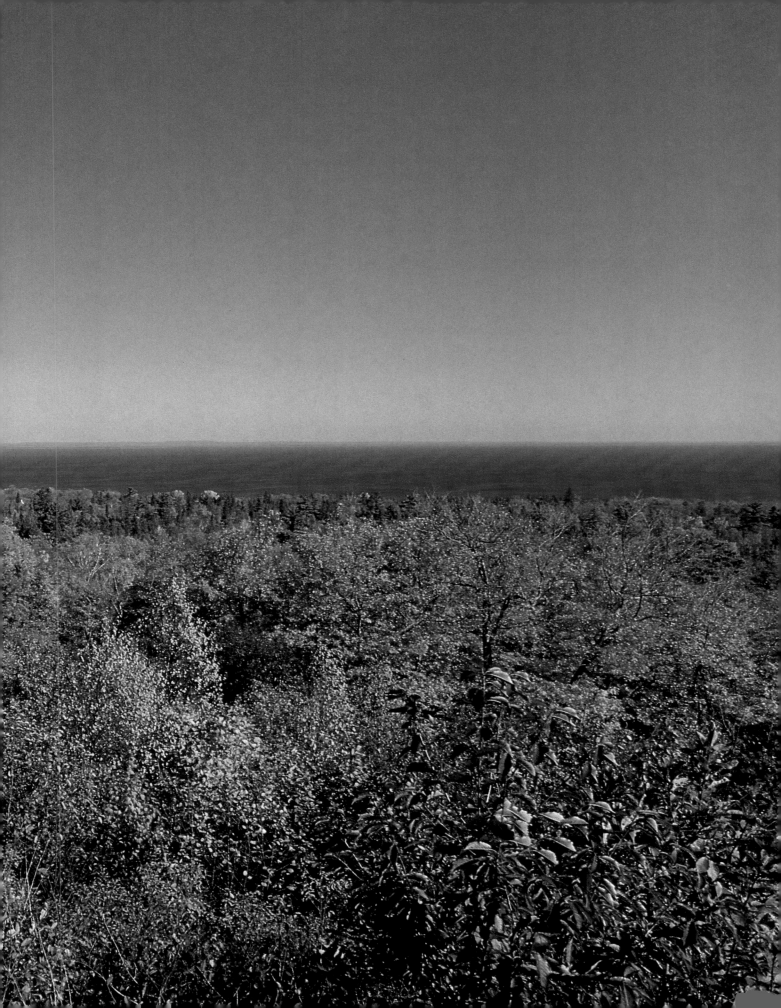

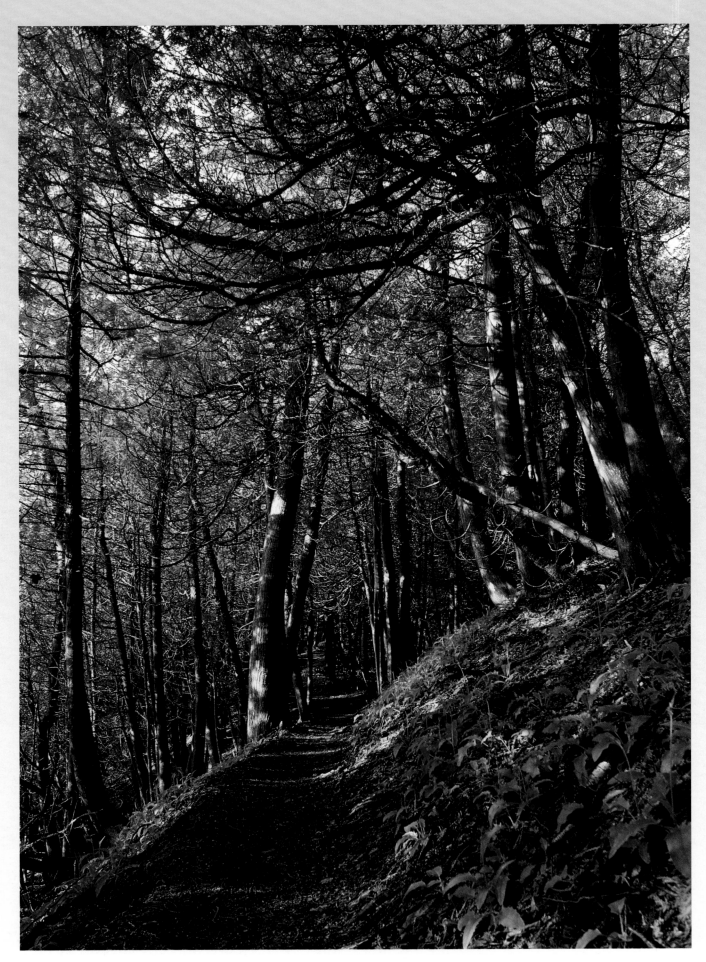

Previous page: A north view from Fort Holmes.

The Manitou Trail leads from Arch Rock to East Bluff.

The links (below) and the clubhouse at Wawashkamo Golf Links.

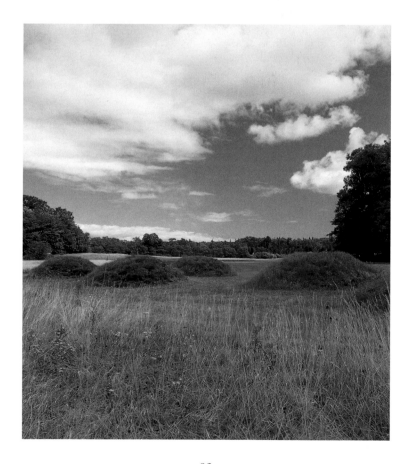

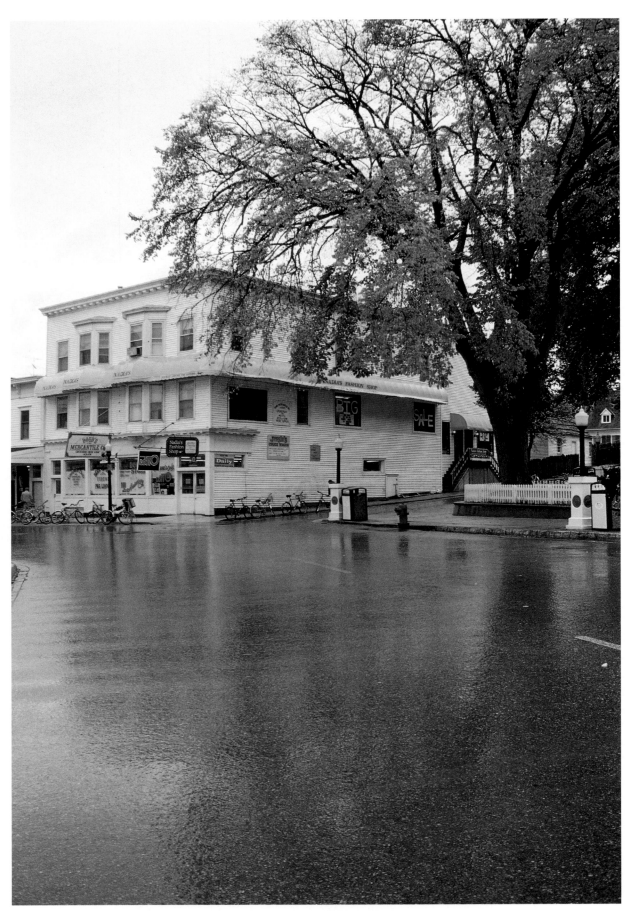

Doud's Mercantile on an October morning.

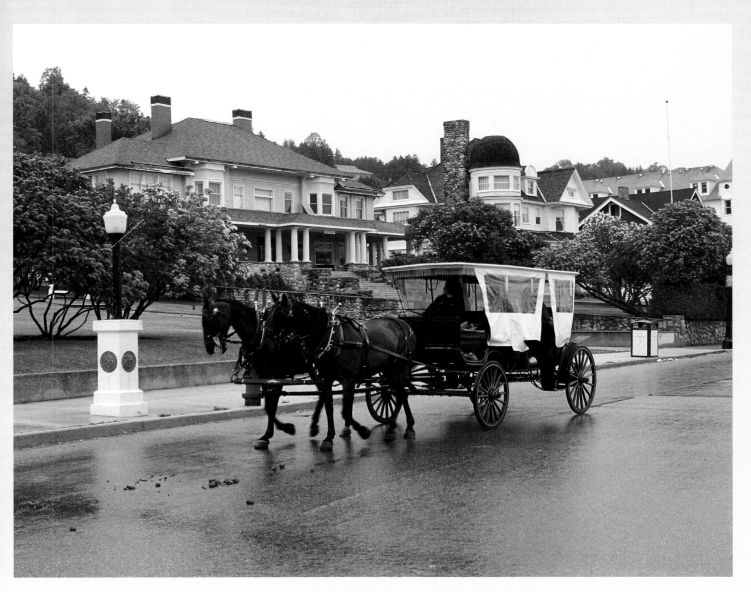

Carriage tour passing Marquette Park with Anne Cottage and Brigadoon in the background.

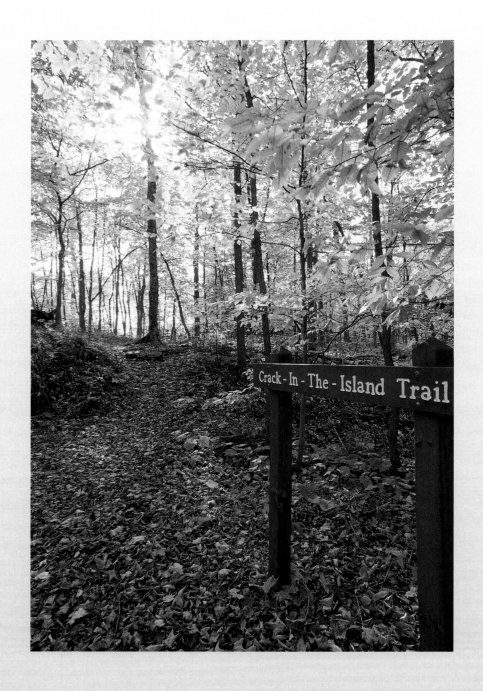

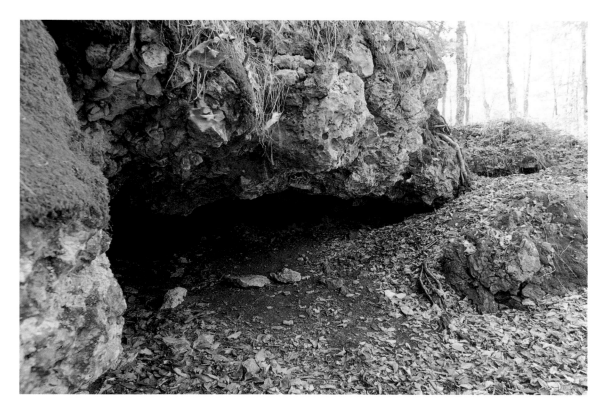

Cave-in-the-Woods.

Crack-in-the-Island.

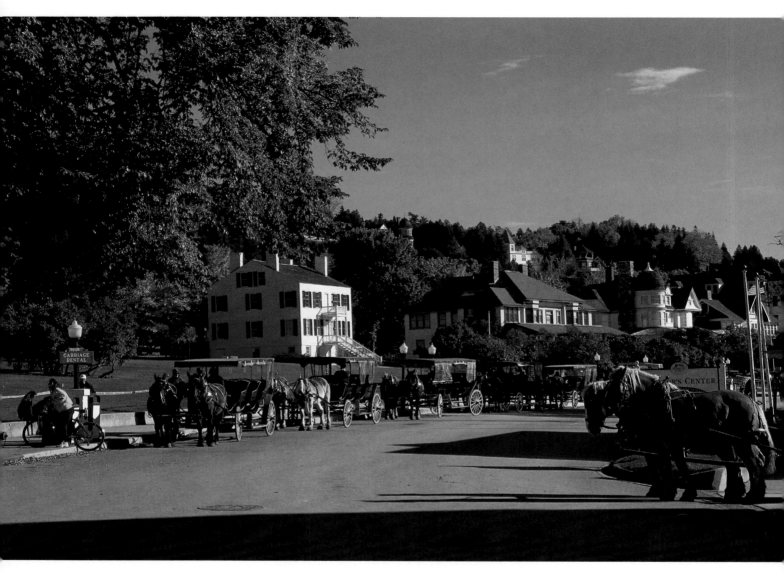

The carriage line waiting for fares along Marquette Park.

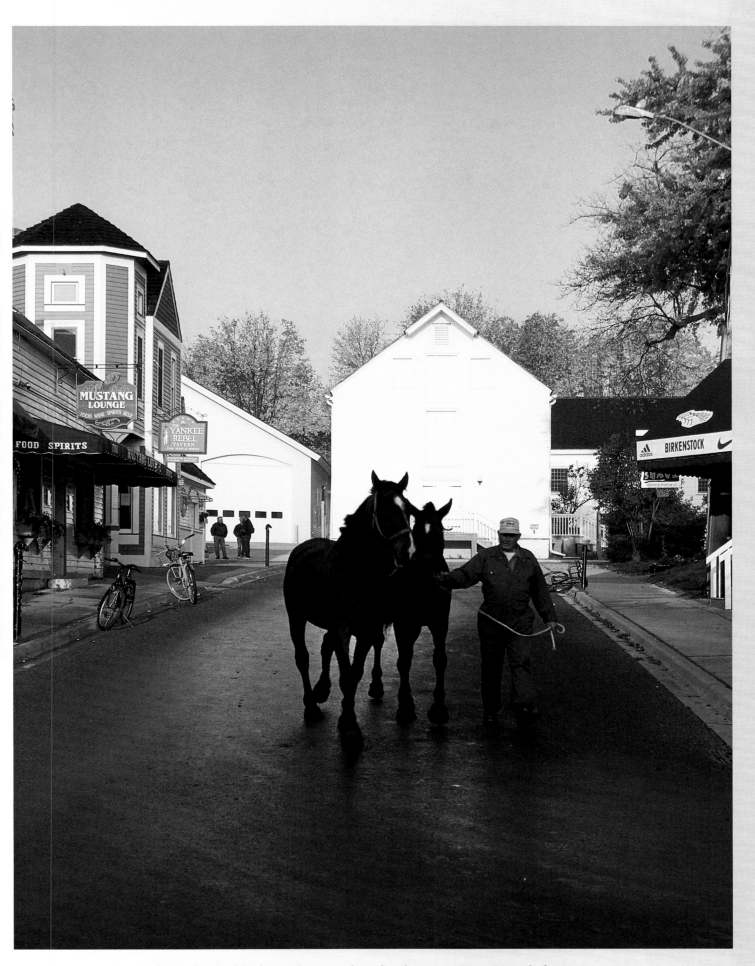

Reducing the island herd. Most horses are shipped to the eastern Upper Peninsula for wintering.

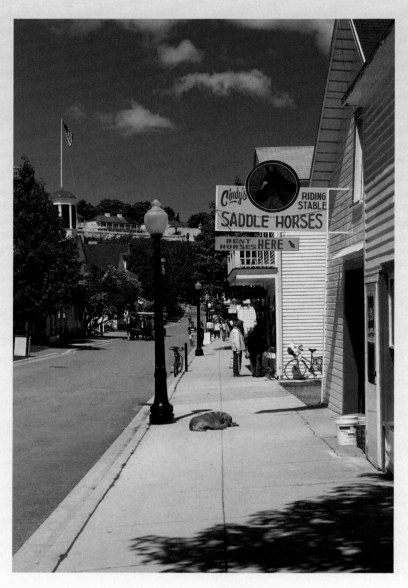

A dog day in June on Market Street.

With the horses wintering in the U.P.,
Cindy's Riding Stable sleeps in the winter.

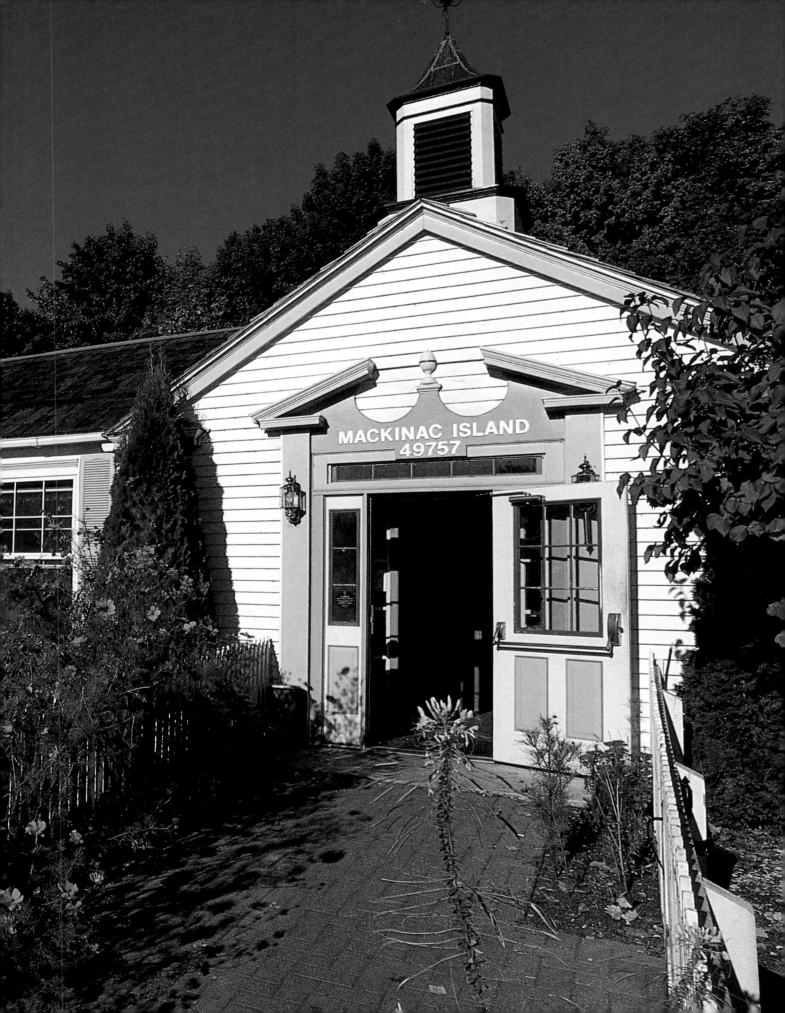

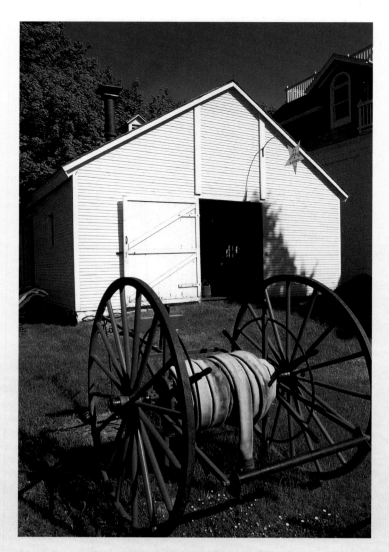

The Benjamin Blacksmith Shop.

Previous page:
The Mackinac Island Post Office
where the islanders pick up their
mail. No rural mail boxes or
addresses are used on the island.

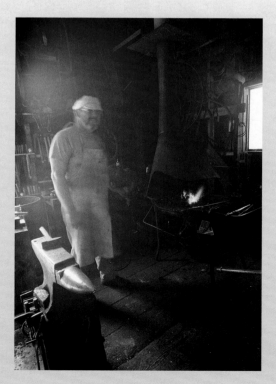

A blacksmith crafting metal art.

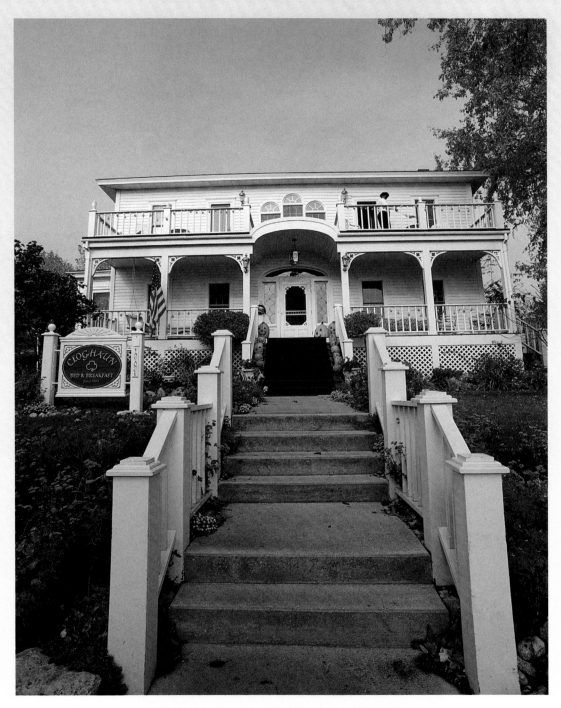

The Cloghaun Bed & Breakfast provides elegant lodging for quieter times on Market Street.

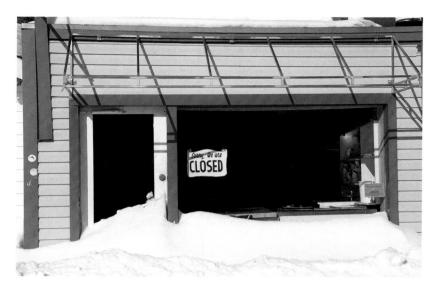

Few businesses remain open during the long winter.

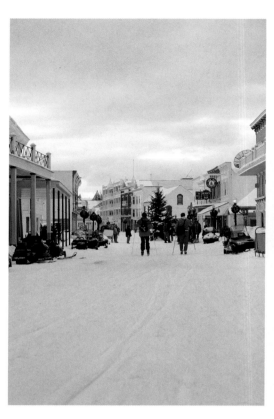

Although Nordic skiing is exceptional, snowmobiles and horse drawn taxis remain the essential modes of winter transportation. Horse drawn sleighs, both private and commercial, are common.

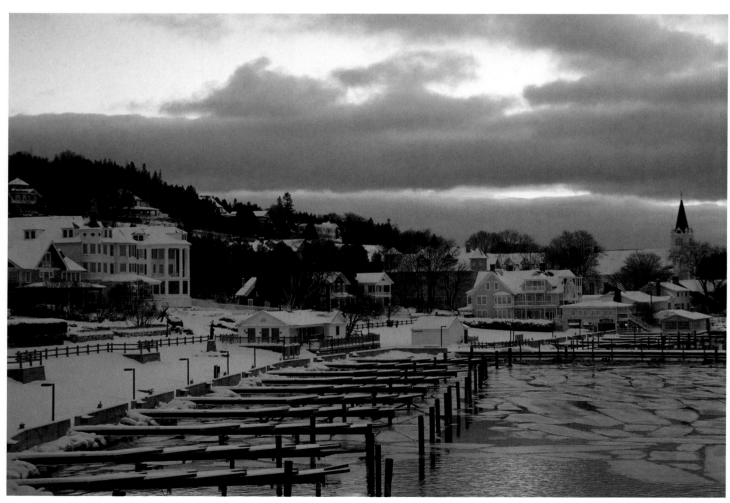

Ice-covered marina slips in late December.

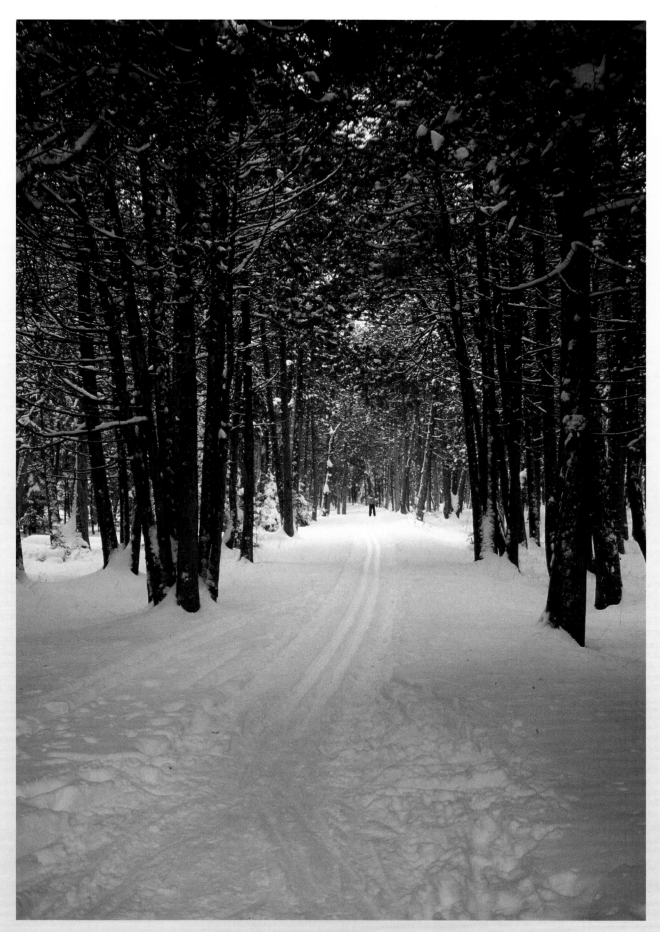

Expertly groomed trails provide miles of remote interior island skiing.

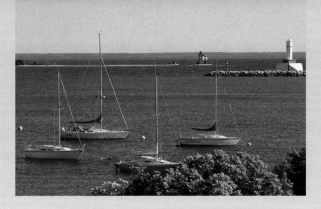

Haldimand Bay from the Harbour View Inn.

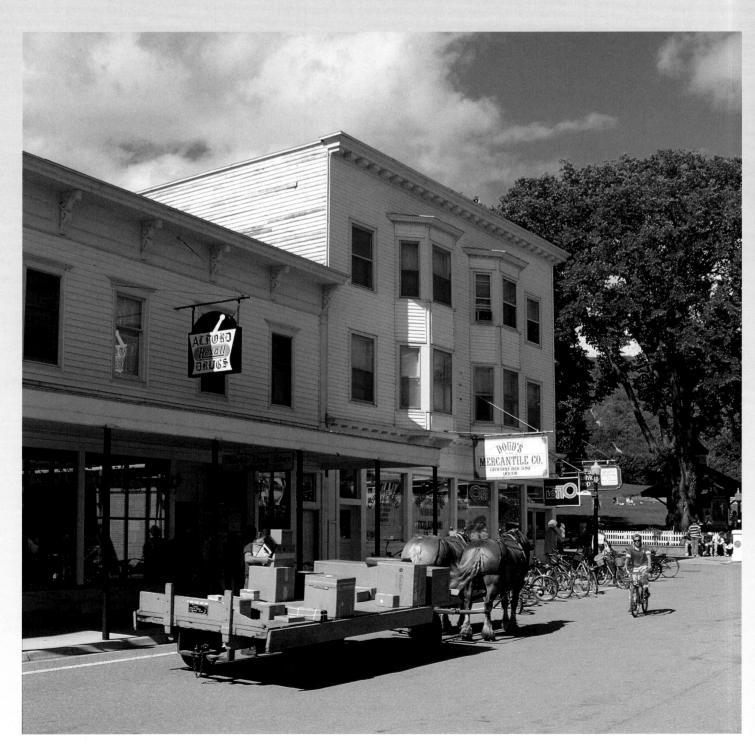

The UPS dray at the drug store.

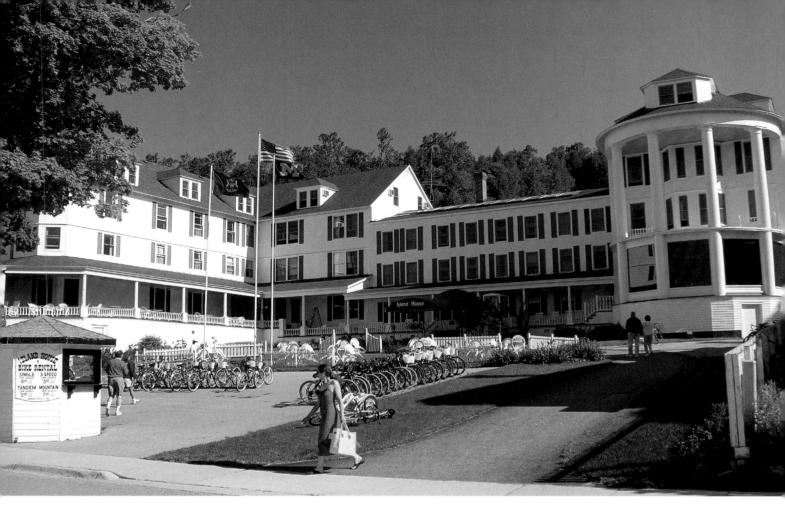

The Island House.

The lilacs along Huron Street. Lilacs were introduced to the island by French missionaries in the 1600's.

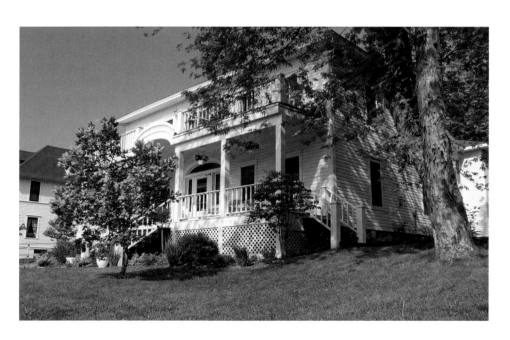

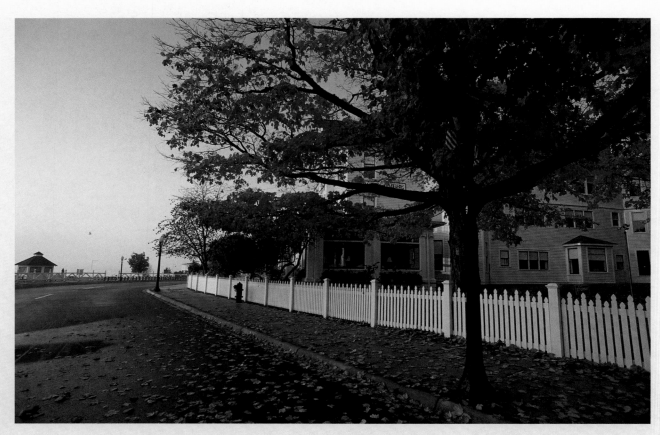

The Windermere Hotel offers peaceful park views along Huron Street across from Windermere Point.

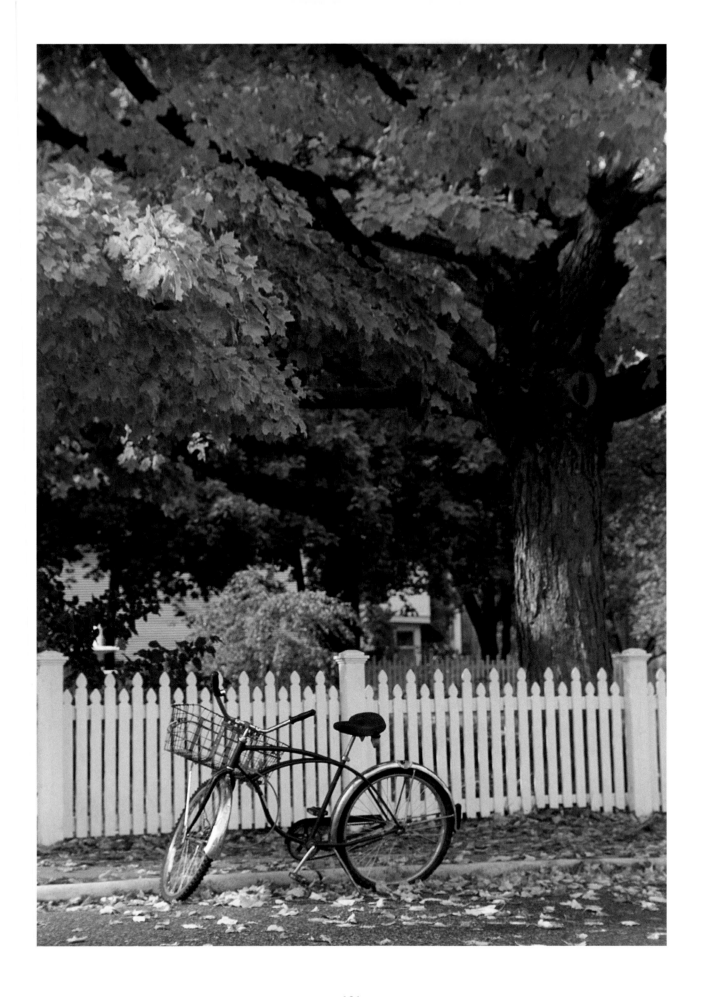

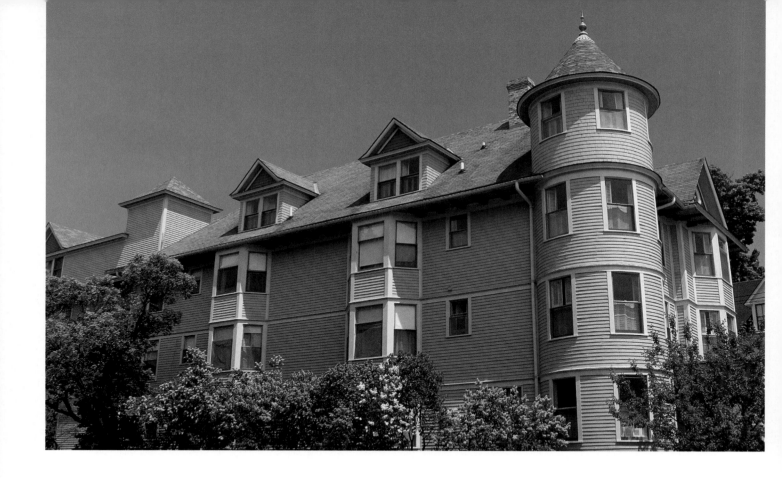

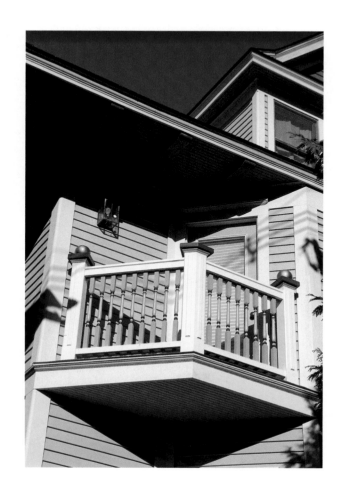

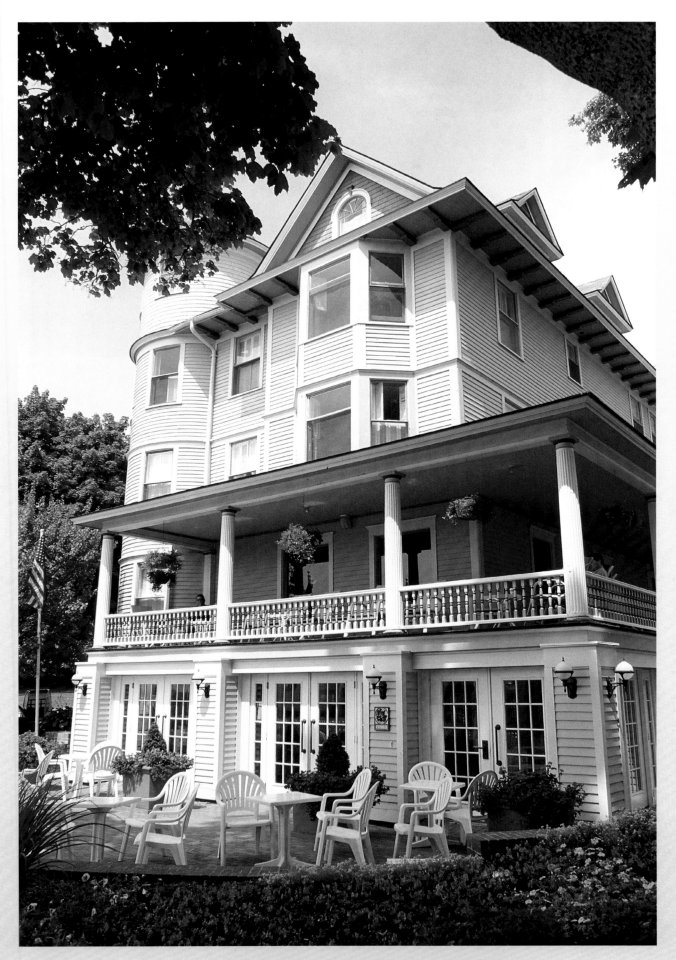

Architecture and detailing at the Inn on Mackinac on Huron Street.

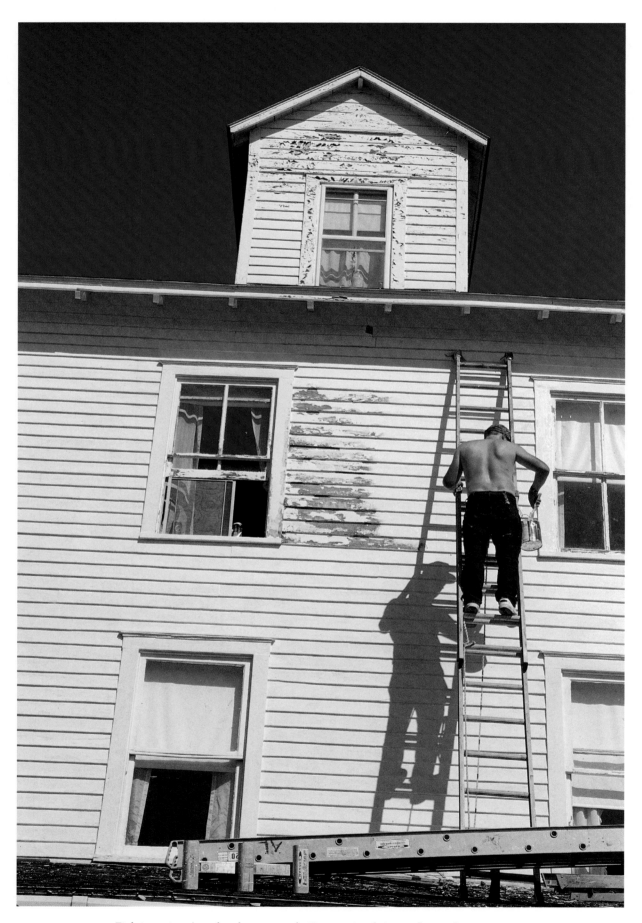

Fighting winter's onslaught never ends. Every spring brings a flurry of maintenance.

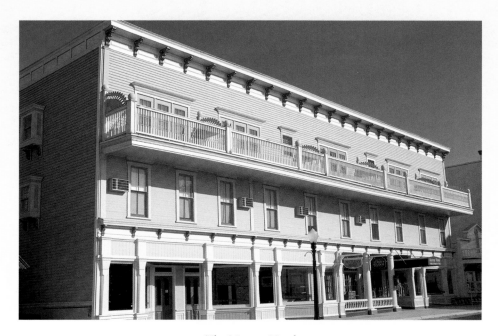

The Murray Hotel.

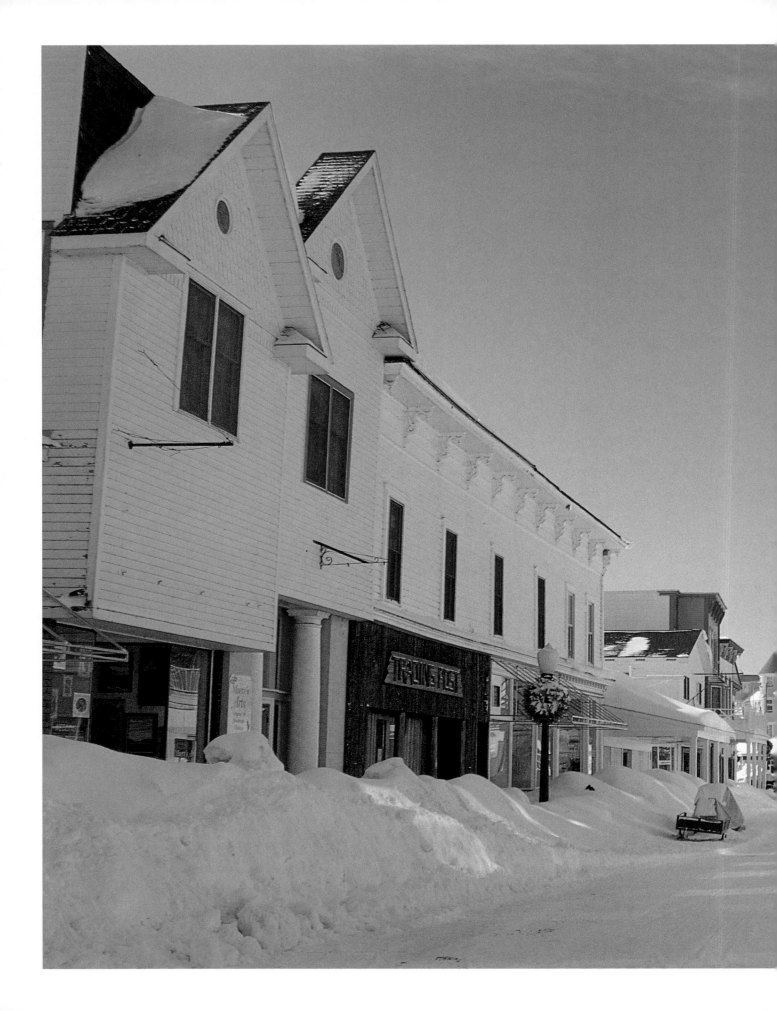

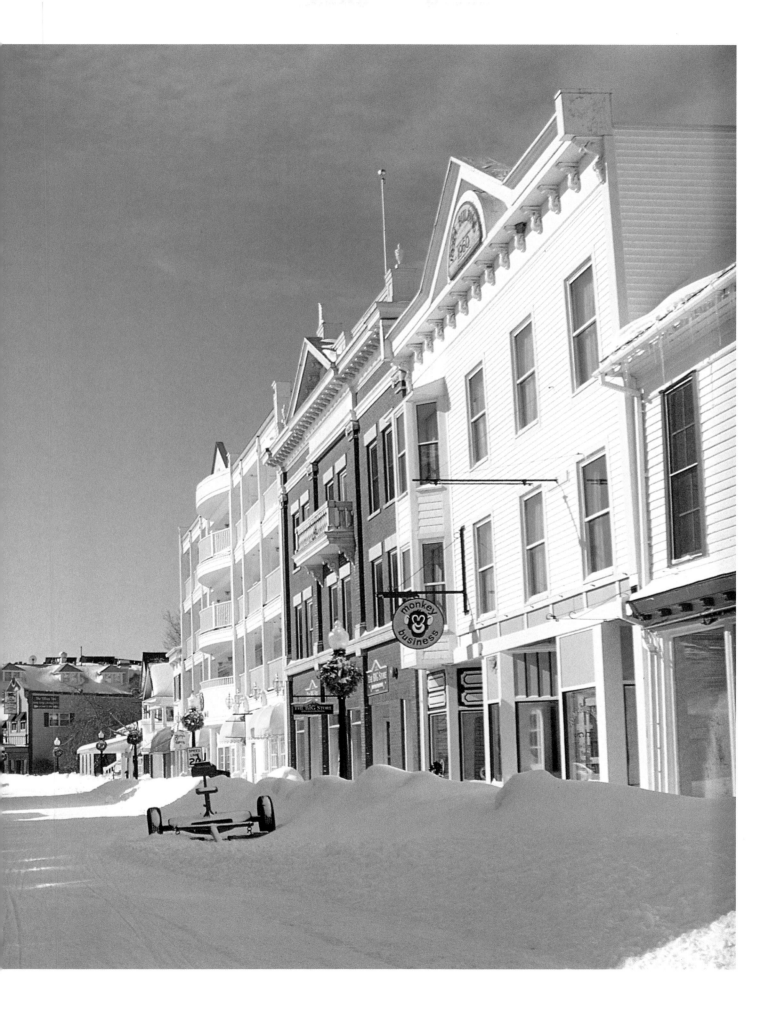

The stairs at Mission Point Resort.

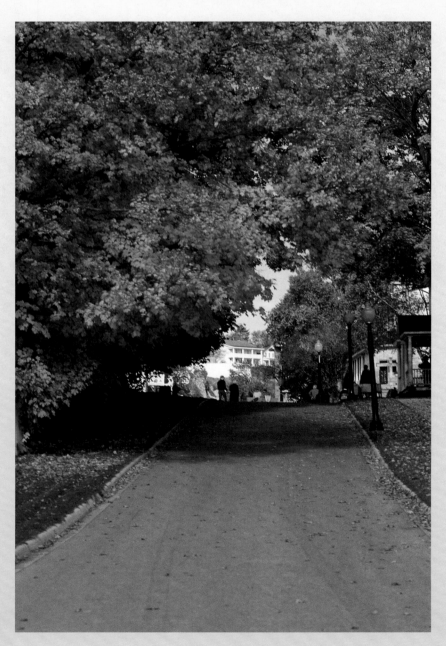

Market Street.

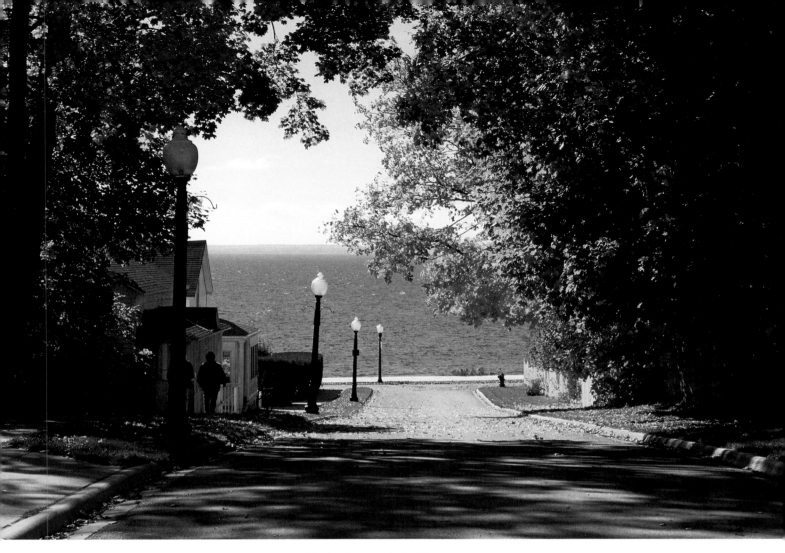

Market Street at Lake Huron.

Hidden secrets along East Bluff.

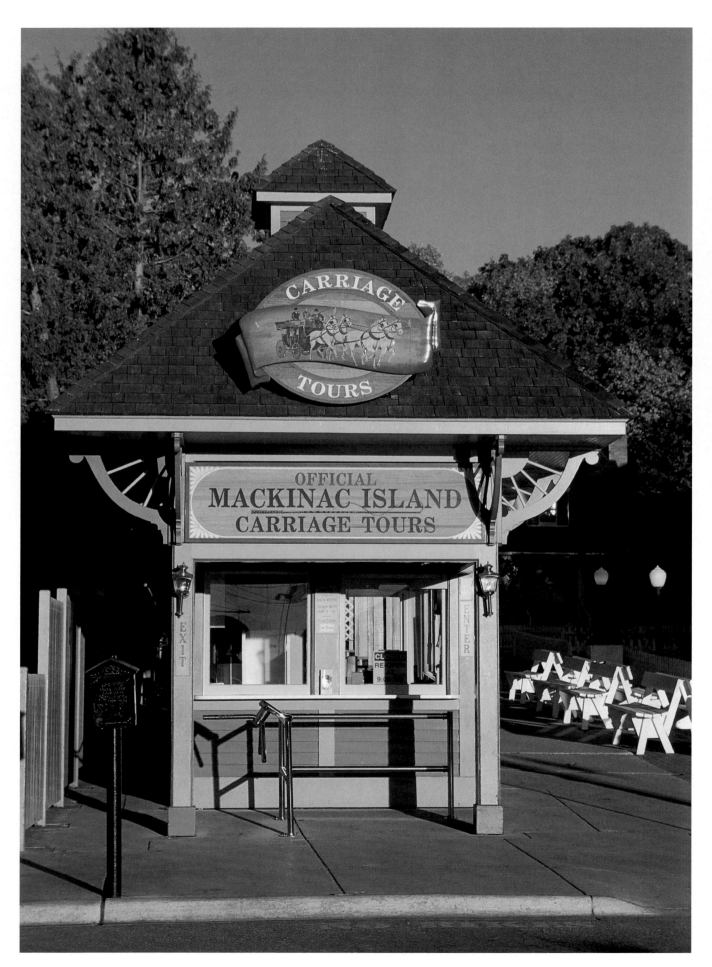

Early morning at the Carriage Tours' booth.

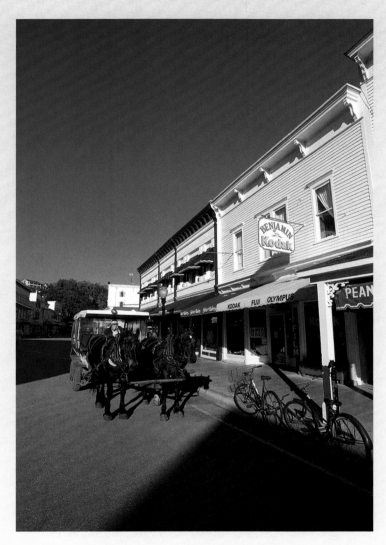

Taxi service—Mackinac Island style!

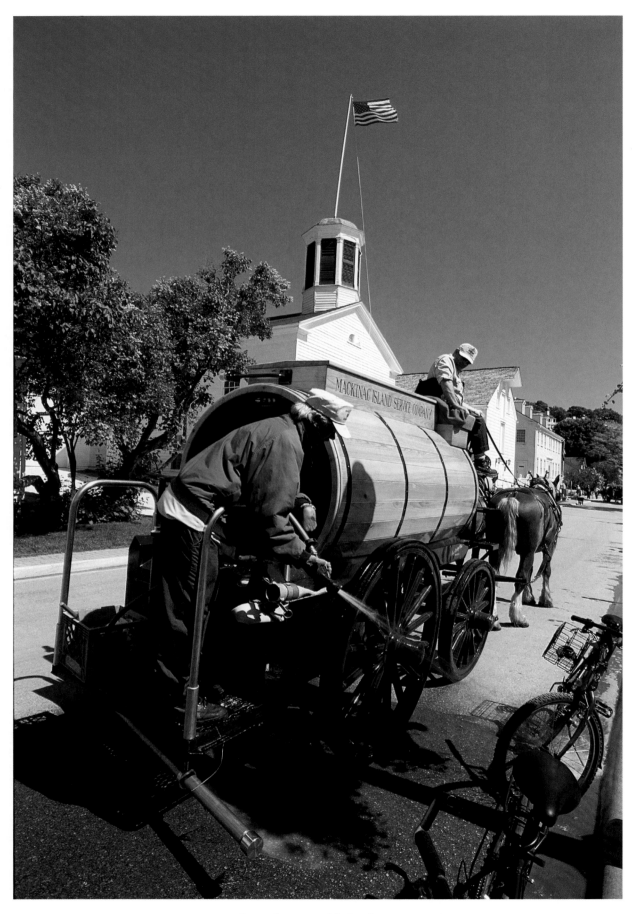

Street cleaners on Market Street.

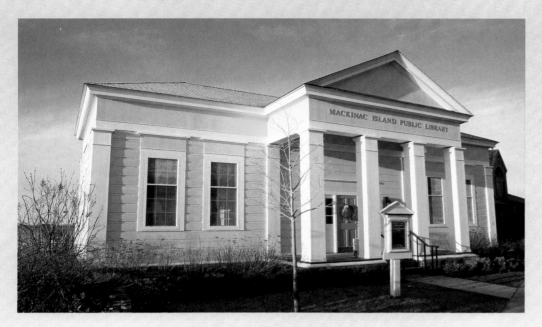

Mackinac Island Public Library.

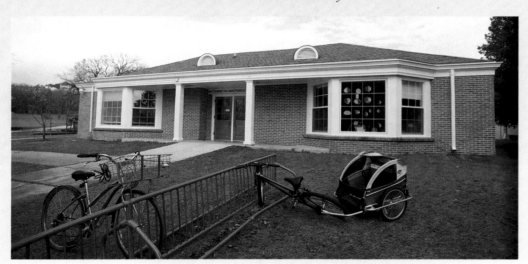

Mackinac Island Public School.

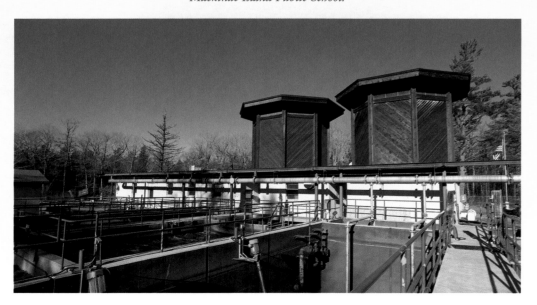

Mackinac Island Sewage Treatment Plant.

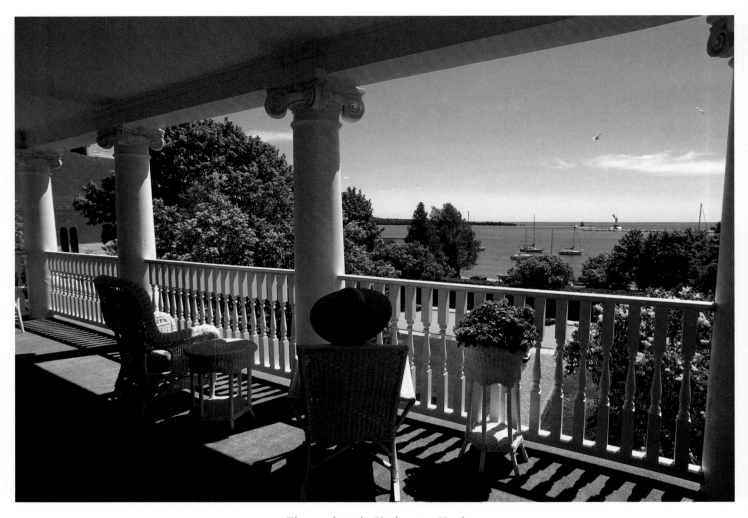

The porch at the Harborview Hotel.

Huron Street.

The Butterfly House on McGulpin Street.

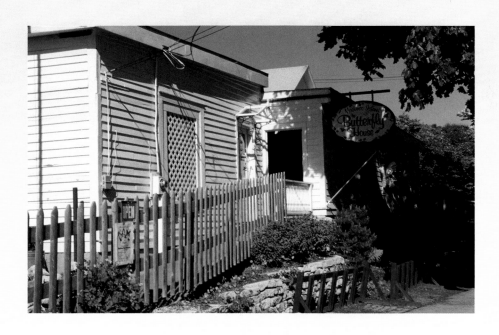

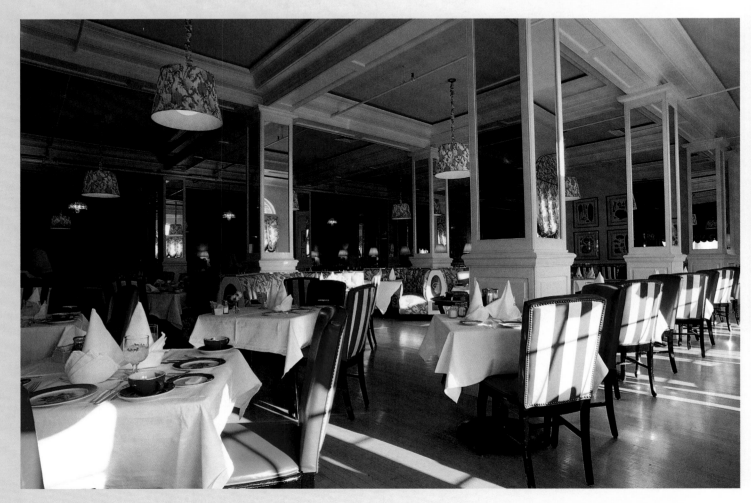

The dining room of the Grand.

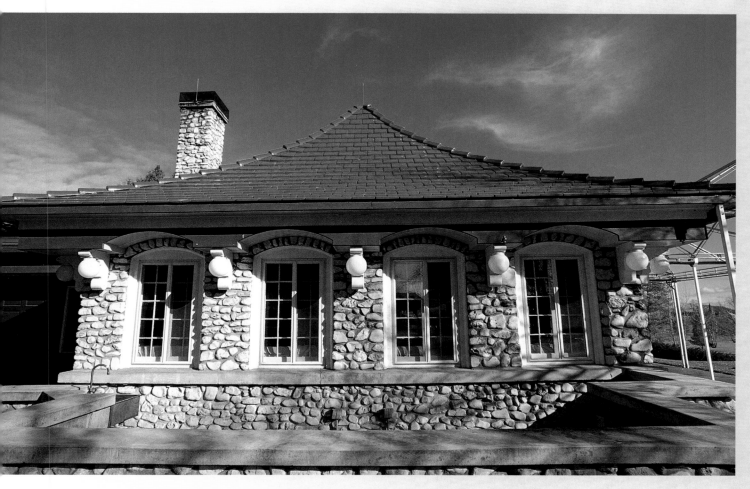

The Jockey Club at the Jewel Golf Course.

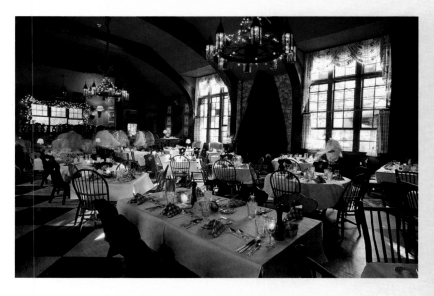

The Woods Restaurant.

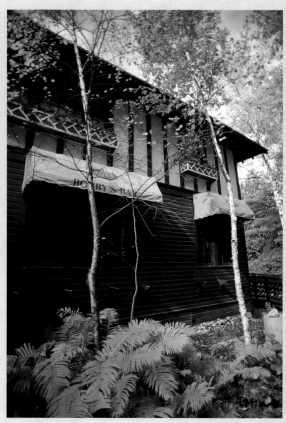

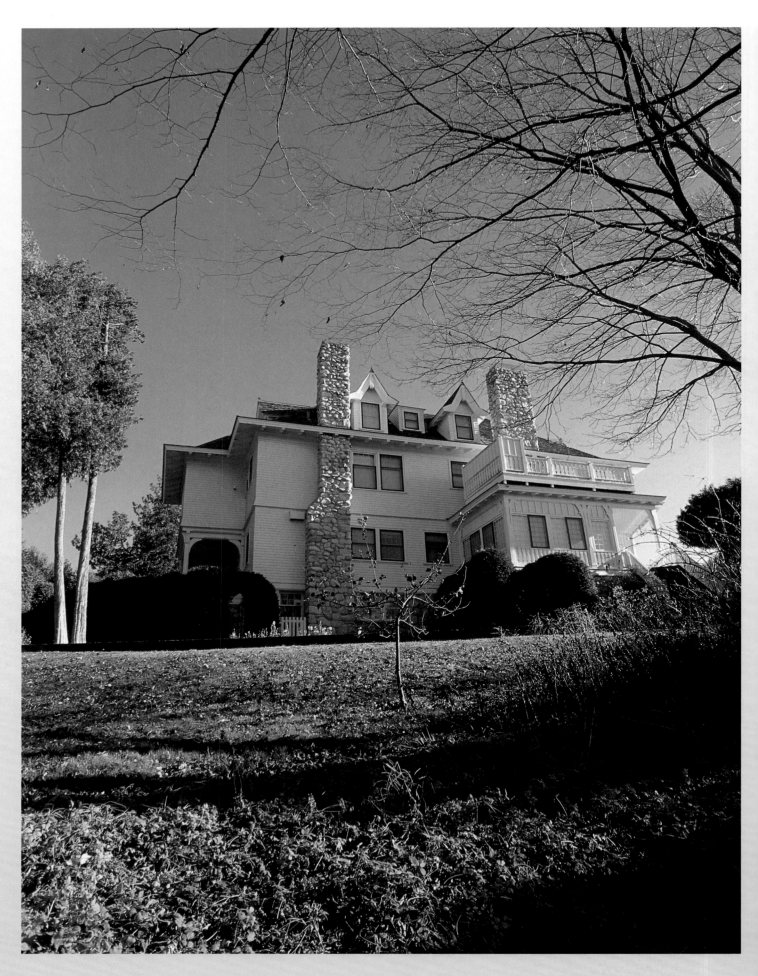

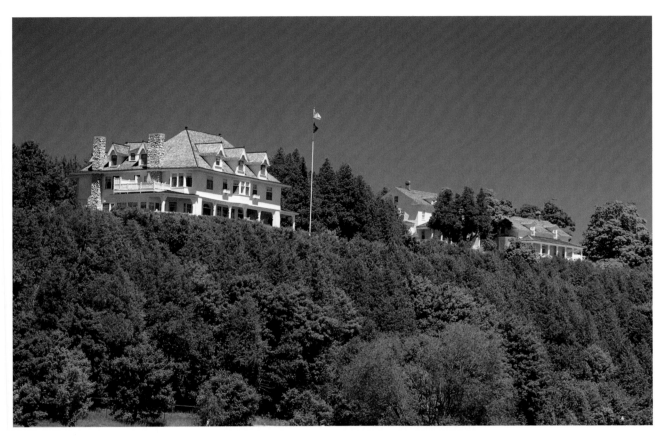

Originally constructed by Patrick Doud in 1902, the twenty-five room home became the Michigan Governor's official summer residence in 1945. The interior, made of Georgian yellow pine, includes eleven bedrooms, eight bathrooms and unlimited views.

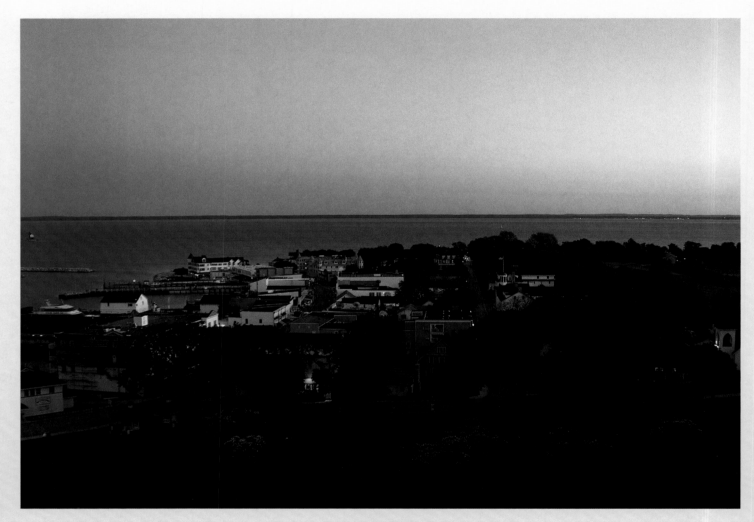

Mid-summer twilight.

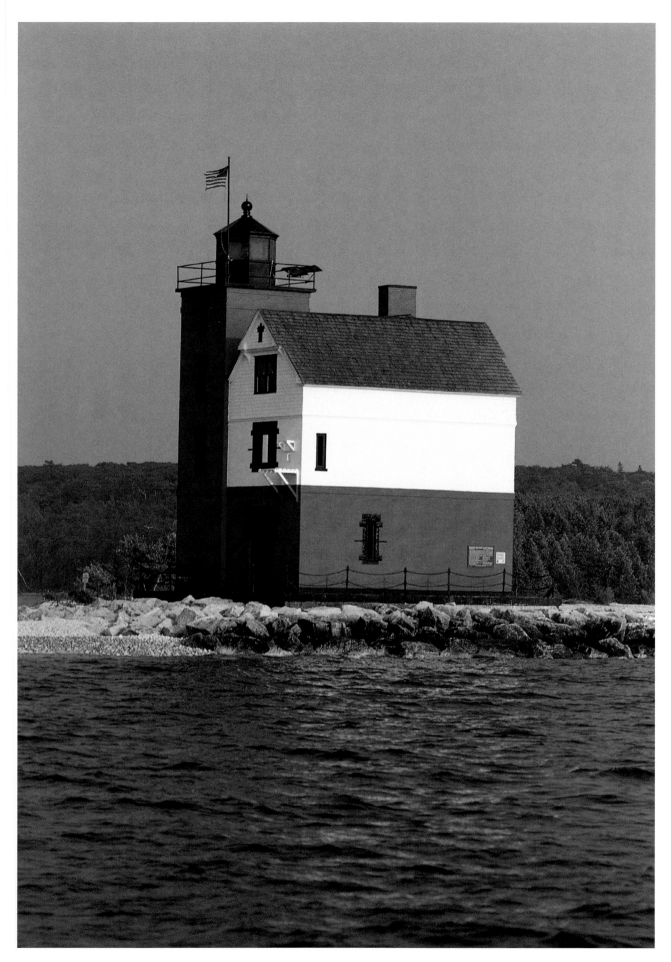

Round Island Lighthouse.

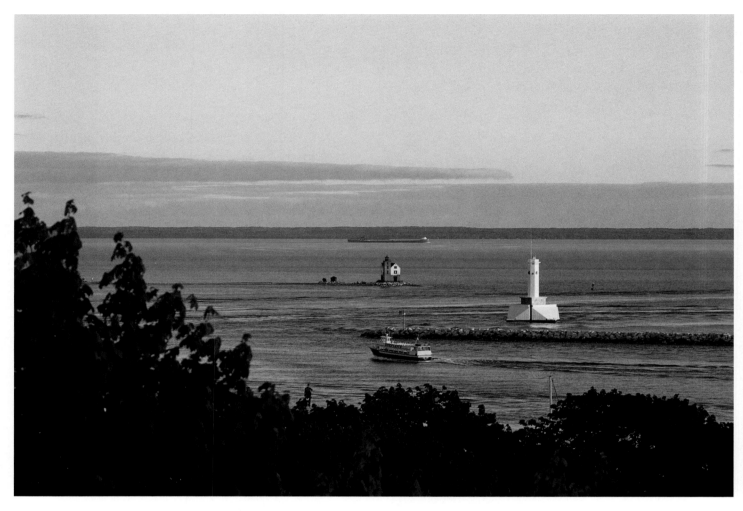

Round Island Lighthouse and the Harbor Light in Haldimand Bay.

A Star Line ferry.

Boats ready for spring fishing on Haldimand Bay.

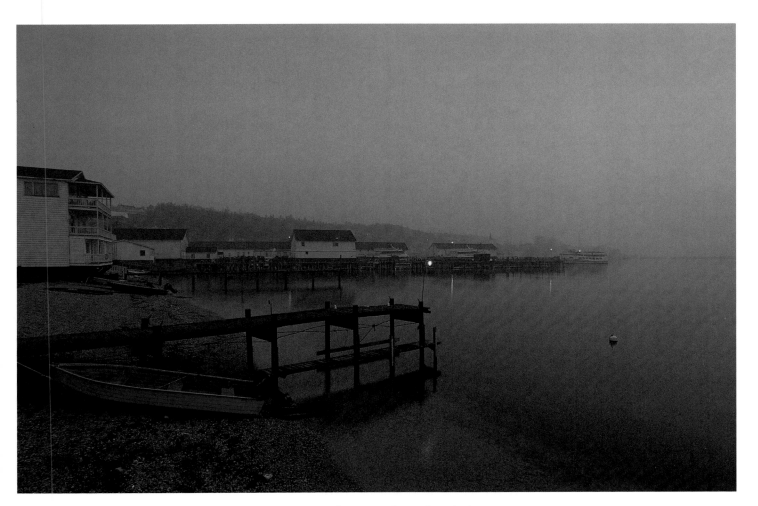

Autumn's early morning haze along the bay.

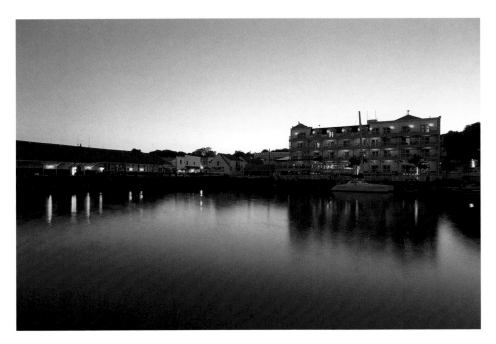

The Chippewa Hotel on Haldimand Bay.

Approximately 500 residents enjoy a tranquil off-season life.

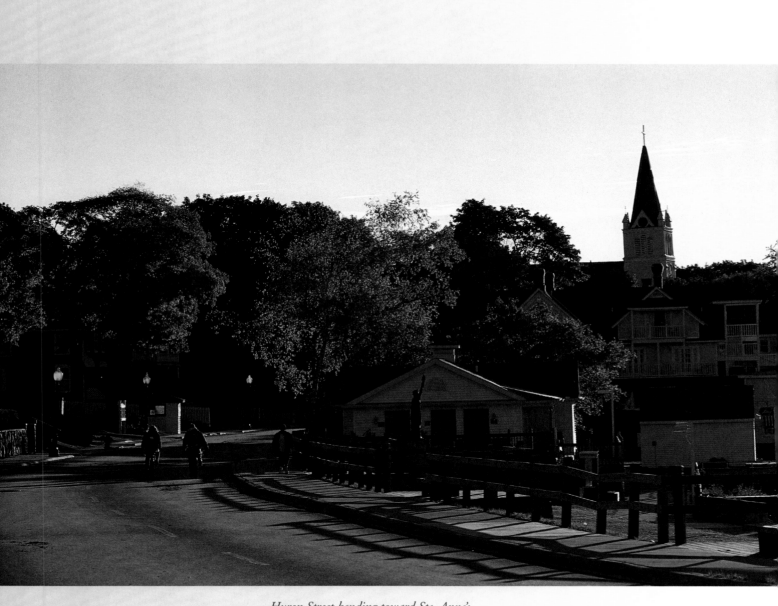

Huron Street bending toward Ste. Anne's.

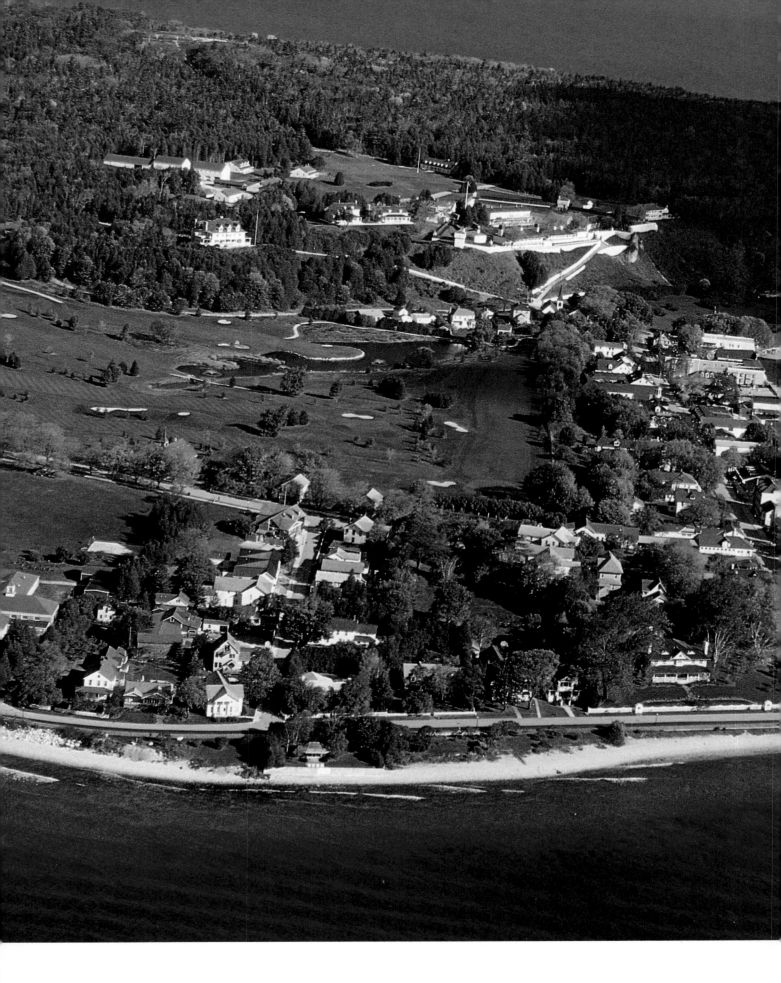

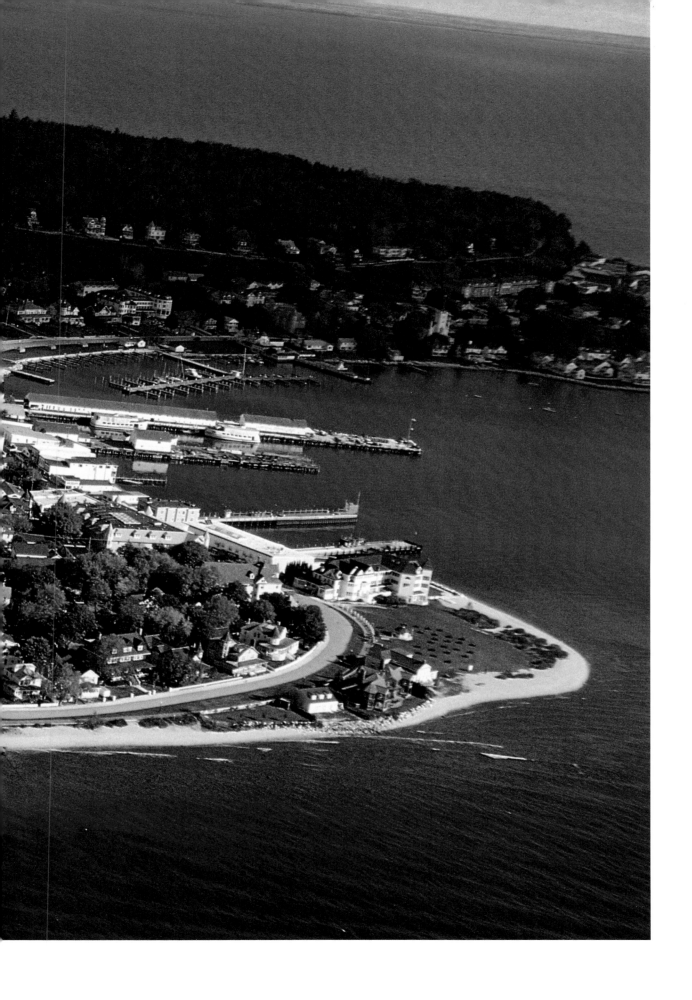